FRUITS AND FLOWERS

2020 Engagement Book

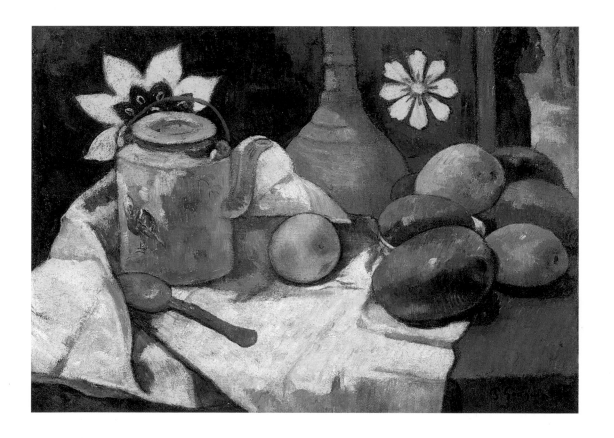

THE METROPOLITAN MUSEUM OF ART

Abrams, New York

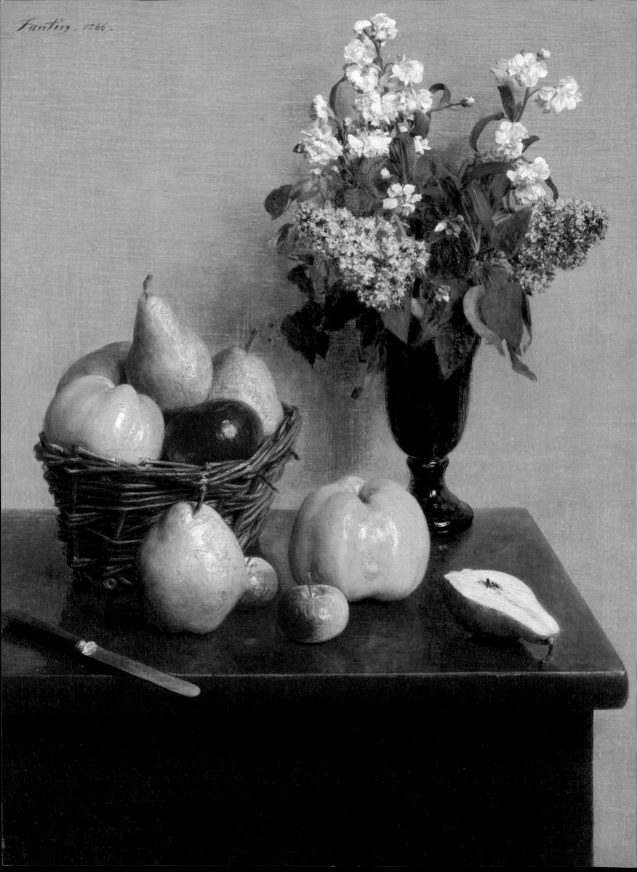

On the title page:

Still Life with Teapot and Fruit
PAUL GAUGUIN (French, 1848–1903)
Oil on canvas, 18 ¾ × 26 in., 1896
The Walter H. and Leonore Annenberg Collection, Gift of Walter H. and Leonore Annenberg, 1997,
Bequest of Walter H. Annenberg, 2002 1997.391.2

GAUGUIN WAS A great admirer of Cézanne, and for many years he owned a still life by the older master. This painting reveals his reverence—an arrangement of ceramic objects and fruit on a folded napkin. But where Cézanne favored apples, Gauguin chose the mangoes of his South Seas retreat, and instead of a pot of primroses, for example, the sunny yellow flowers in the background are stenciled onto the wall covering.

All works are from the collection of The Metropolitan Museum of Art.

Text by Carolyn Vaughan

ISBN: 978-1-4197-3776-3 (hardcover)
ISBN: 978-1-4197-3775-6 (paperback)

Printed and bound in China
**The Metropolitan
Museum of Art**
New York

Abrams® is a registered trademark of Harry N. Abrams, Inc.

ABRAMS
The Art of Books

195 Broadway
New York, NY 10007
abramsbooks.com

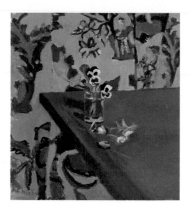

DECEMBER 13–19, 2020

Pansies

HENRI MATISSE (French, 1869–1954)

Oil on paper mounted on paperboard,
19 ¼ × 17 ¾ in., ca. 1903

Bequest of Joan Whitney Payson, 1975
1976.201.22
© 2019 Succession H. Matisse/Artists Rights
Society (ARS), New York

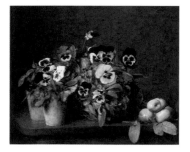

DECEMBER 20–26, 2020

Still Life with Pansies

HENRI FANTIN-LATOUR
(French, 1836–1904)

Oil on canvas,
18 ½ × 22 ¼ in., 1874

The Mr. and Mrs. Henry Ittleson Jr. Purchase
Fund, 1966 66.194

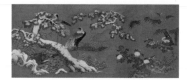

**DECEMBER 27, 2020–
JANUARY 2, 2021**

*Birds and Flowers of the
Four Seasons*

JAPANESE Momoyama period
(1573–1615)

One of a pair of six-panel folding
screens; ink, color, gold, and gold leaf on
paper, 5 ft. 3 ¼ in. × 11 ft. 10 in., second
half of the 16th century

Purchase, Mrs. Jackson Burke and Mary
Livingston Griggs and Mary Griggs Burke
Foundation Gifts, 1987 1987.342.2

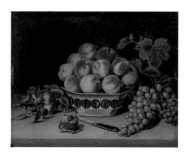

2020–2021 MINI CALENDARS

Still Life: Peaches and Grapes

JOHN A. WOODSIDE
(American, 1781–1852)

Oil on wood, 9 ¾ × 12 ¼ in., ca. 1825

Rogers Fund, 1941 41.152.1

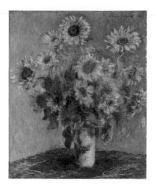

BACK COVER

Bouquet of Sunflowers

CLAUDE MONET
(French, 1840–1926)

Oil on canvas, 39 ¾ × 32 in., 1881

H. O. Havemeyer Collection, Bequest of
Mrs. H. O. Havemeyer, 1929 29.100.107

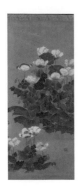

NOVEMBER 1–7, 2020

Poppies

Attributed to KITAGAWA SŌSETSU
(Japanese, active 1639–50)

Hanging scroll; color and gold on paper,
34 ¼ × 14 ⅝ in., mid-17th century

H. O. Havemeyer Collection, Bequest of Mrs.
H. O. Havemeyer, 1929 29.100.524

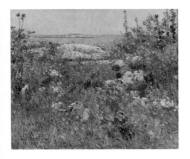

NOVEMBER 8–14, 2020

*Celia Thaxter's Garden,
Isles of Shoals, Maine*

CHILDE HASSAM
(American, 1859–1935)

Oil on canvas,
17 ¾ × 21 ½ in., 1890

Anonymous Gift, 1994 1994.567

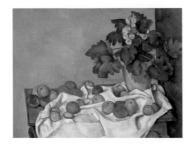

NOVEMBER 15–21, 2020

*Still Life with Apples and a
Pot of Primroses*

PAUL CÉZANNE
(French, 1839–1906)

Oil on canvas, 28 ¾ × 36 ⅜ in., ca. 1890

Bequest of Sam A. Lewisohn, 1951 51.112.1

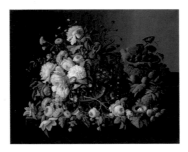

NOVEMBER 22–28, 2020

Still Life: Flowers and Fruit

SEVERIN ROESEN
(American, b. Prussia, 1816–1872?)

Oil on canvas,
40 × 50 ⅜ in., 1850–55

Purchase, Bequest of Charles Allen Munn,
by exchange, Fosburgh Fund Inc. and
Mr. and Mrs. J. William Middendorf II Gifts, and
Henry G. Keasbey Bequest, 1967 67.111

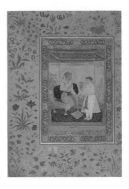

NOVEMBER 29–DECEMBER 5, 2020

Jahangir and His Vizier, Folio
from the *Shah Jahan Album*

Painting by MANOHAR
(Indian, active ca. 1582–1624)

Ink, opaque watercolor, and gold on
paper, 15 ⅜ × 10 ³⁄₁₆ in., ca. 1615

Purchase, Rogers Fund and The Kevorkian
Foundation Gift, 1955 55.121.10.23

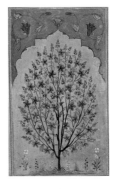

DECEMBER 6–12, 2020

Flowering Tree

INDIAN

Opaque watercolor and gold on paper,
10 ³⁄₁₆ × 7 in., ca. 1700

Bequest of Cora Timken Burnett, 1956
57.51.34

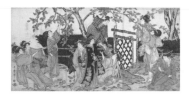

SEPTEMBER 20–26, 2020

Picking Persimmons
KITAGAWA UTAMARO
(Japanese, ca. 1754–1806)

Triptych of polychrome woodblock
prints; ink and color on paper, 15 × 30 in.,
ca. 1802–4

Gift of Estate of Samuel Isham, 1914 JP994

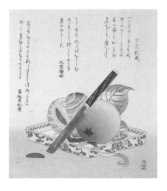

SEPTEMBER 27–OCTOBER 3, 2020

Persimmons on a Plate
KUBO SHUNMAN
(Japanese, 1757–1820)

Polychrome woodblock print (surimono);
ink and color on paper, 8 ⅛ × 7 ¹⁄₁₆ in.,
19th century

H. O. Havemeyer Collection, Bequest of
Mrs. H. O. Havemeyer, 1929 JP2120

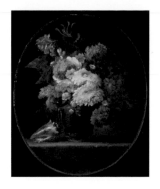

OCTOBER 4–10, 2020

Vase of Flowers and Conch Shell
ANNE VALLAYER-COSTER
(French, 1744–1818)

Oil on canvas,
19 ¾ × 15 in., 1780

Gift of J. Pierpont Morgan, 1906 07.225.504

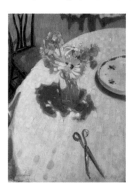

OCTOBER 11–17, 2020

Mauve Primulas on a Table
WILLIAM NICHOLSON
(British, 1872–1949)

Oil on wood,
23 ¾ × 16 ¾ in., 1928

Bequest of Mary Cushing Fosburgh, 1978
1979.135.15
© Desmond Banks

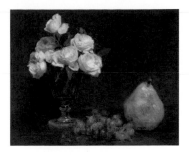

OCTOBER 18–24, 2020

Still Life with Roses and Fruit
HENRI FANTIN-LATOUR
(French, 1836–1904)

Oil on canvas,
13 ⅝ × 16 ⅜ in., 1863

Bequest of Alice A. Hay, 1987 1987.119

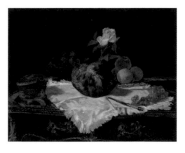

OCTOBER 25–31, 2020

The Brioche
ÉDOUARD MANET
(French, 1832–1883)

Oil on canvas,
25 ⅝ × 31 ⅞ in., 1870

Gift and Bequest of David and Peggy
Rockefeller, 1991, 2017 1991.287

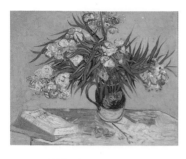

AUGUST 9–15, 2020

Oleanders

VINCENT VAN GOGH
(Dutch, 1853–1890)

Oil on canvas, 23 ¾ × 29 in., 1888

Gift of Mr. and Mrs. John L. Loeb, 1962 62.24

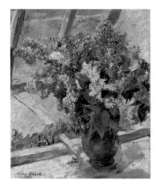

AUGUST 16–22, 2020

Lilacs in a Window

MARY CASSATT
(American, 1844–1926)

Oil on canvas,
24 ³⁄₁₆ × 20 ⅛ in., ca. 1880–83

Partial and Promised Gift of
Mr. and Mrs. Douglas Dillon, 1997 1997.207

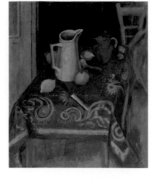

AUGUST 23–29, 2020

The Red Tablecloth

SAMUEL HALPERT
(American, b. Russia, 1884–1930)

Oil on canvas,
30 ⅛ × 25 ⅛ in., 1915

Anonymous Gift, 1994 1994.394

AUGUST 30–SEPTEMBER 5, 2020

Peach Blossoms at My Window
from *Wilderness Colors*

SHITAO (ZHU RUOJI)
(Chinese, 1642–1707)

One from an album of twelve paintings;
ink and color on paper, 10 ⅞ × 9 ½ in.,
ca. 1700

The Sackler Fund, 1972 1972.122a–l

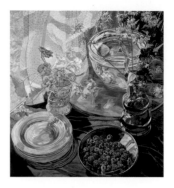

SEPTEMBER 6–12, 2020

Raspberries and Goldfish

JANET FISH (American, b. 1938)

Oil on linen with acrylic gesso ground,
72 × 64 in., 1981

Purchase, The Cape Branch Foundation and
Lila Acheson Wallace Gifts, 1983 1983.171
© Janet Fish

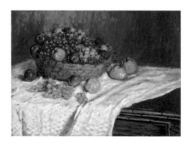

SEPTEMBER 13–19, 2020

Apples and Grapes

CLAUDE MONET
(French, 1840–1926)

Oil on canvas,
26 ⅝ × 35 ¼ in., 1879–80

Gift of Henry R. Luce, 1957 57.183

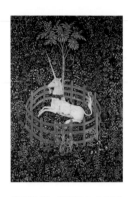

JUNE 28–JULY 4, 2020

The Unicorn in Captivity
from the Unicorn Tapestries
SOUTH NETHERLANDISH
Wool warp with wool, silk, silver, and gilt
wefts, 12 ft. ⅞ in. × 8 ft. 3 in., 1495–1505

Gift of John D. Rockefeller Jr., 1937 37.80.6

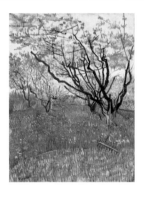

JULY 5–11, 2020

The Flowering Orchard
VINCENT VAN GOGH
(Dutch, 1853–1890)

Oil on canvas, 28 ½ × 21 in., 1888

The Mr. and Mrs. Henry Ittleson Jr.
Purchase Fund, 1956 56.13

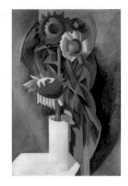

JULY 12–18, 2020

Sunflowers
EDWARD MCKNIGHT KAUFFER
(American, 1890–1954)

Oil on canvas, 36 × 24 in., 1921

Purchase, The Mrs. Claus von Bulow Fund
Gift, 1987 1987.5

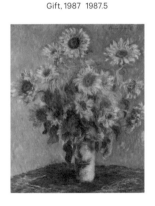

JULY 19–25, 2020

Bouquet of Sunflowers
CLAUDE MONET
(French, 1840–1926)

Oil on canvas, 39 ¾ × 32 in., 1881

H. O. Havemeyer Collection, Bequest of
Mrs. H. O. Havemeyer, 1929 29.100.107

JULY 26–AUGUST 1, 2020

Big Table with Pomegranates
NELL BLAINE (American, 1922–1996)

Oil on canvas, 22 × 26 in., 1978

Gift of Arthur W. Cohen, 1985 1985.36.1

AUGUST 2–8, 2020

Fruit or Pomegranate
WILLIAM MORRIS (British, 1834–1896)
Made by MORRIS & COMPANY

Block-printed wallpaper, 27 ¹/₁₆ × 21 ⅝ in.,
designed 1865–66

Purchase, Edward C. Moore Jr. Gift, 1923
23.163.4g

MAY 17–23, 2020

Spring (Fruit Trees in Bloom)

CLAUDE MONET (French, 1840–1926)

Oil on canvas,
24 ½ × 39 ⅝ in., 1873

Bequest of Mary Livingston Willard, 1926
26.186.1

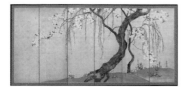

MAY 24–30, 2020

Cherry Trees

SAKAI HŌITSU (Japanese, 1761–1828)
One of a pair of six-panel folding screens;
ink, color, and gold leaf on paper,
5 ft. 8 ⅞ in. × 11 ft. 9 in., early 1820s

Purchase, Mary and James G. Wallach
Foundation Gift, Rogers and Mary Livingston
Griggs and Mary Griggs Burke Foundation
Funds, and Brooke Russell Astor Bequest,
2018 2018.55.1

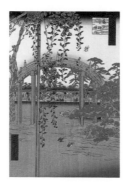

MAY 31–JUNE 6, 2020

*In the Kameido Tenjin
Shrine Compound*

UTAGAWA HIROSHIGE
(Japanese, 1797–1858)

Polychrome woodblock print; ink and
color on paper, 14 ¼ × 9 ¾ in., 1856

The Howard Mansfield Collection, Purchase,
Rogers Fund, 1936 JP2517

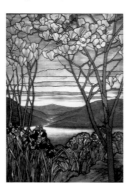

JUNE 7–13, 2020

Magnolias and Irises

LOUIS COMFORT TIFFANY
(American, 1848–1933)
Made by TIFFANY STUDIOS
(American, 1902–1932)

Leaded Favrile glass, 60 ¼ × 42 in.,
ca. 1908

Anonymous Gift, in memory of
Mr. and Mrs. A. B. Frank, 1981 1981.159

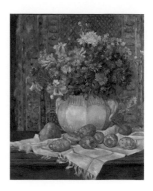

JUNE 14–20, 2020

*Still Life with Flowers
and Prickly Pears*

AUGUSTE RENOIR
(French, 1841–1919)

Oil on canvas,
28 ⅞ × 23 ⅜ in., ca. 1885

Bequest of Catherine Vance Gaisman, 2010
2010.454

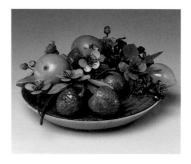

JUNE 21–27, 2020

Dish of Fruit and Peach Blossoms

CHINESE, Qing dynasty (1644–1911)

Jade (jadeite) and various stones,
amber, glass, bone, and feathers,
18th–19th century

Gift of Heber R. Bishop, 1902 02.18.746

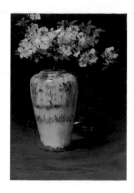

MARCH 29–APRIL 4, 2020

Pink Azalea—Chinese Vase
WILLIAM MERRITT CHASE
(American, 1849–1916)
Oil on wood,
23 ½ × 16 ⁹⁄₁₆ in., 1880–90?
Gift of Mrs. J. Augustus Barnard, 1979
1979.490.5

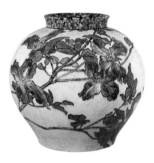

APRIL 5–11, 2020

Vase
JOHN BENNETT
(American, 1840–1907)
Painted and glazed earthenware, 1882
Friends of the American Wing Fund,
1984 1984.425

APRIL 12–18, 2020

Dogwood
LOUIS COMFORT TIFFANY
(American, 1848–1933)
Made by TIFFANY STUDIOS
(American, 1902–1932)
Leaded Favrile glass,
8 ft. 4 in. × 4 ft. 8 in., ca. 1902–15
Gift of Frank Stanton, in memory of Ruth
Stephenson Stanton, 1995 1995.204

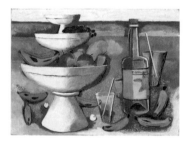

APRIL 19–25, 2020

The White Fruit Bowl
RUFINO TAMAYO (Mexican, 1899–1991)
Oil on canvas, 18 × 23 ⅝ in., 1938
From the Collection of Dr. and Mrs. Samuel
Ernest Sussman, Bequest of Blanche Risa
Sussman, 1990 1991.129.6
© 2019 Tamayo Heirs / Mexico / Licensed by
VAGA at Artists Rights Society (ARS),
New York

APRIL 26–MAY 2, 2020

Still Life with Strawberries
FRENCH, 17th century
Oil on canvas, 23 ⅝ × 31 ⅝ in.
Bequest of Harry G. Sperling, 1971
1976.100.10

MAY 3–9, 2020

Still Life with Apples and Pears
PAUL CÉZANNE (French, 1839–1906)
Oil on canvas, 17 ⅝ × 23 ⅛ in.,
ca. 1891–92
Bequest of Stephen C. Clark, 1960 61.101.3

MAY 10–16, 2020

Gathering Fruit
MARY CASSATT
(American, 1844–1926)
Drypoint, softground etching, and
aquatint, 20 ½ x 15 ⅞ in., ca. 1893
Rogers Fund, 1918 18.33.4

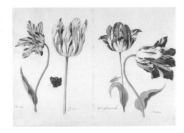

FEBRUARY 9–15, 2020

Four Tulips

JACOB MARREL
(German, 1613/14–1681)

Watercolor on vellum, 13 ⅜ × 17 ¹¹⁄₁₆ in.,
ca. 1635–45

Rogers Fund, 1968 68.66

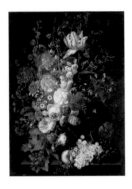

FEBRUARY 16–22, 2020

A Vase of Flowers

MARGARETA HAVERMAN
(Dutch, active by 1716–d. 1722 or later)
Oil on wood, 31 ¼ × 23 ¾ in., 1716

Purchase, 1871 71.6

FEBRUARY 23–29, 2020

Daisy

WILLIAM MORRIS (British, 1834–1896)
Made by MORRIS & COMPANY

Block-printed wallpaper, 27 × 21 ½ in.,
designed 1864

Purchase, Edward C. Moore Jr. Gift,
1923 23.163.4b

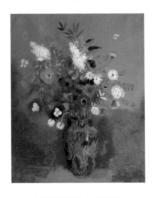

MARCH 1–7, 2020

Bouquet of Flowers

ODILON REDON (French, 1840–1916)

Pastel on paper, 31 ⅝ × 25 ¼ in.,
ca. 1900–1905

Gift of Mrs. George B. Post, 1956 56.50

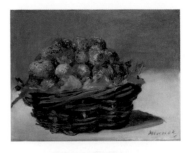

MARCH 8–14, 2020

Strawberries

ÉDOUARD MANET (French, 1832–1883)

Oil on canvas,
8 ⅜ × 10 ½ in., ca. 1882

Gift of Mr. and Mrs. Nate B. Spingold,
1956 56.230.1

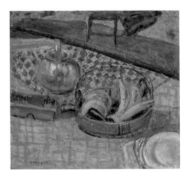

MARCH 15–21, 2020

Basket of Bananas

PIERRE BONNARD
(French, 1867–1947)

Oil on canvas,
23 ⅝ × 25 ¼ in., 1926

Jacques and Natasha Gelman Collection,
1998 1999.363.7
© 2019 Artists Rights Society (ARS), New York

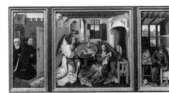

MARCH 22–28, 2020

*Annunciation Triptych
(Merode Altarpiece)*

Workshop of ROBERT CAMPIN
(Netherlandish, ca. 1375–1444)

Oil on oak, overall (open):
25 ⅜ × 46 ⅜ in., ca. 1427–32

The Cloisters Collection, 1956 56.70a–c

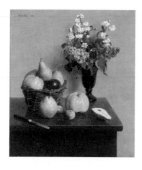

FRONT COVER AND INTRODUCTION

Still Life with Flowers and Fruit
HENRI FANTIN-LATOUR
(French, 1836–1904)

Oil on canvas,
28 ¾ × 23 ⅝ in., 1866

Purchase, Mr. and Mrs. Richard J. Bernhard
Gift, by exchange, 1980 1980.3

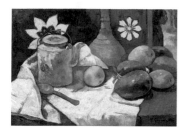

TITLE PAGE

Still Life with Teapot and Fruit
PAUL GAUGUIN (French, 1848–1903)

Oil on canvas, 18 ¾ × 26 in., 1896

The Walter H. and Leonore Annenberg
Collection, Gift of Walter H. and Leonore
Annenberg, 1997, Bequest of Walter H.
Annenberg, 2002 1997.391.2

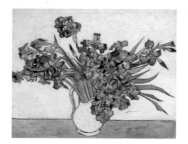

**DECEMBER 29, 2019–
JANUARY 4, 2020**

Irises
VINCENT VAN GOGH
(Dutch, 1853–1890)

Oil on canvas,
29 × 36 ¼ in., 1890

Gift of Adele R. Levy, 1958 58.187

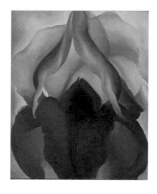

JANUARY 5–11, 2020

Black Iris
GEORGIA O'KEEFFE
(American, 1887–1986)

Oil on canvas,
36 × 29 ⅞ in., 1926

Alfred Stieglitz Collection, 1969 69.278.1

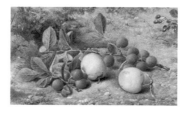

JANUARY 12–18, 2020

Plums
JOHN WILLIAM HILL
(American, b. England, 1812–1879)

Watercolor, graphite, and gouache,
7 ⅛ × 12 in., 1870

Gift of J. Henry Hill, 1882 82.9.1

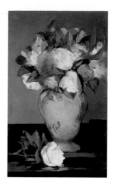

JANUARY 19–25, 2020

Peonies
ÉDOUARD MANET
(French, 1832–1883)

Oil on canvas,
23 ⅜ × 13 ⅞ in., 1864–65

Bequest of Joan Whitney Payson,
1975 1976.201.16

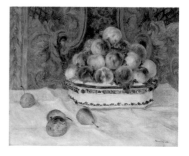

JANUARY 26–FEBRUARY 1, 2020

Still Life with Peaches
AUGUSTE RENOIR (French, 1841–1919)

Oil on canvas, 21 × 25 ½ in., 1881

Bequest of Stephen C. Clark, 1960 61.101.12

FEBRUARY 2–8, 2020

One Hundred Flowers
After YUN SHOUPING
(Chinese, 1633–1690)

Handscroll, ink and color on silk,
1 ft. 4 ½ in. × 21 ft. 3 ½ in, 18th century

Bequest of John M. Crawford, Jr., 1988
1989.363.149

JANUARY

S	M	T	W	T	F	S
			1	2	3	4
5	6	7	8	9	10	11
12	13	14	15	16	17	18
19	20	21	22	23	24	25
26	27	28	29	30	31	

FEBRUARY

S	M	T	W	T	F	S
						1
2	3	4	5	6	7	8
9	10	11	12	13	14	15
16	17	18	19	20	21	22
23	24	25	26	27	28	29

MARCH

S	M	T	W	T	F	S
1	2	3	4	5	6	7
8	9	10	11	12	13	14
15	16	17	18	19	20	21
22	23	24	25	26	27	28
29	30	31				

APRIL

S	M	T	W	T	F	S
			1	2	3	4
5	6	7	8	9	10	11
12	13	14	15	16	17	18
19	20	21	22	23	24	25
26	27	28	29	30		

MAY

S	M	T	W	T	F	S
					1	2
3	4	5	6	7	8	9
10	11	12	13	14	15	16
17	18	19	20	21	22	23
24	25	26	27	28	29	30
31						

JUNE

S	M	T	W	T	F	S
	1	2	3	4	5	6
7	8	9	10	11	12	13
14	15	16	17	18	19	20
21	22	23	24	25	26	27
28	29	30				

JULY

S	M	T	W	T	F	S
			1	2	3	4
5	6	7	8	9	10	11
12	13	14	15	16	17	18
19	20	21	22	23	24	25
26	27	28	29	30	31	

AUGUST

S	M	T	W	T	F	S
						1
2	3	4	5	6	7	8
9	10	11	12	13	14	15
16	17	18	19	20	21	22
23	24	25	26	27	28	29
30	31					

SEPTEMBER

S	M	T	W	T	F	S
		1	2	3	4	5
6	7	8	9	10	11	12
13	14	15	16	17	18	19
20	21	22	23	24	25	26
27	28	29	30			

OCTOBER

S	M	T	W	T	F	S
				1	2	3
4	5	6	7	8	9	10
11	12	13	14	15	16	17
18	19	20	21	22	23	24
25	26	27	28	29	30	31

NOVEMBER

S	M	T	W	T	F	S
1	2	3	4	5	6	7
8	9	10	11	12	13	14
15	16	17	18	19	20	21
22	23	24	25	26	27	28
29	30					

DECEMBER

S	M	T	W	T	F	S
		1	2	3	4	5
6	7	8	9	10	11	12
13	14	15	16	17	18	19
20	21	22	23	24	25	26
27	28	29	30	31		

JANUARY

S	M	T	W	T	F	S
					1	2
3	4	5	6	7	8	9
10	11	12	13	14	15	16
17	18	19	20	21	22	23
24	25	26	27	28	29	30
31						

FEBRUARY

S	M	T	W	T	F	S
	1	2	3	4	5	6
7	8	9	10	11	12	13
14	15	16	17	18	19	20
21	22	23	24	25	26	27
28						

MARCH

S	M	T	W	T	F	S
	1	2	3	4	5	6
7	8	9	10	11	12	13
14	15	16	17	18	19	20
21	22	23	24	25	26	27
28	29	30	31			

APRIL

S	M	T	W	T	F	S
				1	2	3
4	5	6	7	8	9	10
11	12	13	14	15	16	17
18	19	20	21	22	23	24
25	26	27	28	29	30	

MAY

S	M	T	W	T	F	S
						1
2	3	4	5	6	7	8
9	10	11	12	13	14	15
16	17	18	19	20	21	22
23	24	25	26	27	28	29
30	31					

JUNE

S	M	T	W	T	F	S
		1	2	3	4	5
6	7	8	9	10	11	12
13	14	15	16	17	18	19
20	21	22	23	24	25	26
27	28	29	30			

JULY

S	M	T	W	T	F	S
				1	2	3
4	5	6	7	8	9	10
11	12	13	14	15	16	17
18	19	20	21	22	23	24
25	26	27	28	29	30	31

AUGUST

S	M	T	W	T	F	S
1	2	3	4	5	6	7
8	9	10	11	12	13	14
15	16	17	18	19	20	21
22	23	24	25	26	27	28
29	30	31				

SEPTEMBER

S	M	T	W	T	F	S
			1	2	3	4
5	6	7	8	9	10	11
12	13	14	15	16	17	18
19	20	21	22	23	24	25
26	27	28	29	30		

OCTOBER

S	M	T	W	T	F	S
					1	2
3	4	5	6	7	8	9
10	11	12	13	14	15	16
17	18	19	20	21	22	23
24	25	26	27	28	29	30
31						

NOVEMBER

S	M	T	W	T	F	S
	1	2	3	4	5	6
7	8	9	10	11	12	13
14	15	16	17	18	19	20
21	22	23	24	25	26	27
28	29	30				

DECEMBER

S	M	T	W	T	F	S
			1	2	3	4
5	6	7	8	9	10	11
12	13	14	15	16	17	18
19	20	21	22	23	24	25
26	27	28	29	30	31	

Still Life: Peaches and Grapes
(detail)
JOHN A. WOODSIDE (American, 1781–1852)
Oil on wood, 9 ¾ × 12 ¼ in., ca. 1825
Rogers Fund, 1941 41.152.1

WHILE RENOIR WAS once a porcelain painter (week of January 26), Woodside started out as a sign painter. In America at that time, still life was disdained as a genre appropriate only for women and amateurs, but a few artists, including Woodside, defied that attitude. The angled knife is a convention in still-life painting to lead the viewer in and to create a sense of depth, but here it is also functional: to slice into the juicy peaches.

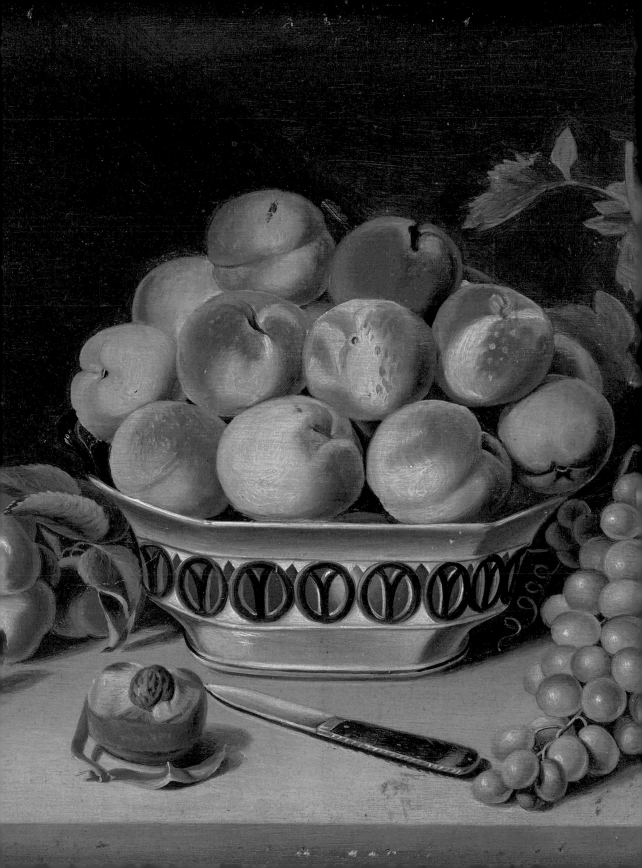

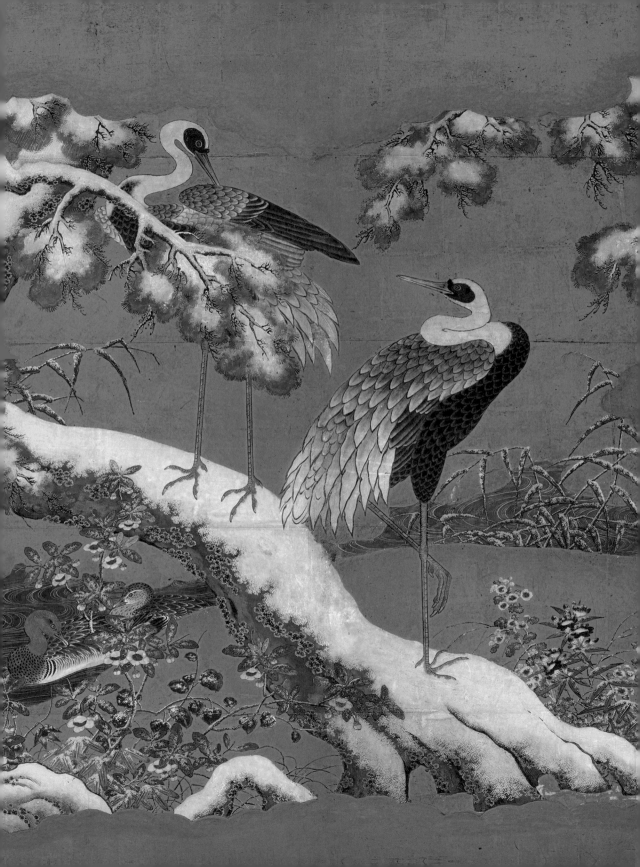

27 *Sunday*

28 *Monday*

BOXING DAY OBSERVED (CAN, UK, AUS, NZ)
ST. STEPHEN'S DAY OBSERVED (IRL)

29 *Tuesday*

○

30 *Wednesday*

31 *Thursday*

1 *Friday*

NEW YEAR'S DAY

2 *Saturday*

JANUARY 2021

S	M	T	W	T	F	S
					1	2
3	4	5	6	7	8	9
10	11	12	13	14	15	16
17	18	19	20	21	22	23
24	25	26	27	28	29	30
31						

PART OF A depiction of the progression of the seasons, painted on two six-panel screens in rich color on gold, this scene—read from right to left—shows autumn turning to winter. Pink-and-white flowers, associated with fall, give way to a magnificent, snow-laden pine. Evergreens were highly regarded in Japan, and outings to admire them in winter were the equivalent of flower viewing in spring.

Birds and Flowers of the Four Seasons (detail)

JAPANESE, Momoyama period (1573–1615)

One of a pair of six-panel folding screens; ink, color, gold, and gold leaf on paper, 5 ft. 3 ¼ in. × 11 ft. 10 in., second half of the 16th century

Purchase, Mrs. Jackson Burke and Mary Livingston Griggs and Mary Griggs Burke Foundation Gifts, 1987 1987.342.2

20 *Sunday*

21 *Monday*

22 *Tuesday*

23 *Wednesday*

24 *Thursday*

25 *Friday*

CHRISTMAS DAY

26 *Saturday*

KWANZAA BEGINS (US)
BOXING DAY (CAN, UK, AUS, NZ)
ST. STEPHEN'S DAY (IRL)

Still Life with Pansies (detail)
HENRI FANTIN-LATOUR
(French, 1836–1904)
Oil on canvas, 18 ½ × 22 ¼ in., 1874
The Mr. and Mrs. Henry Ittleson Jr. Purchase Fund, 1966 66.194

FANTIN-LATOUR avowed a "horror of movement, of animated scenes," yet his still lifes, while serene, are far from static. These pansies' filmy petals seem almost to flutter, and the clutch of apples, with leaves extending over the lip of the table, looks spontaneously placed. But since the fruit appears in fall and the flowers in spring, the artist must have chosen and arranged the objects with his usual deliberation.

DECEMBER						
S	M	T	W	T	F	S
		1	2	3	4	5
6	7	8	9	10	11	12
13	14	15	16	17	18	19
20	21	22	23	24	25	26
27	28	29	30	31		

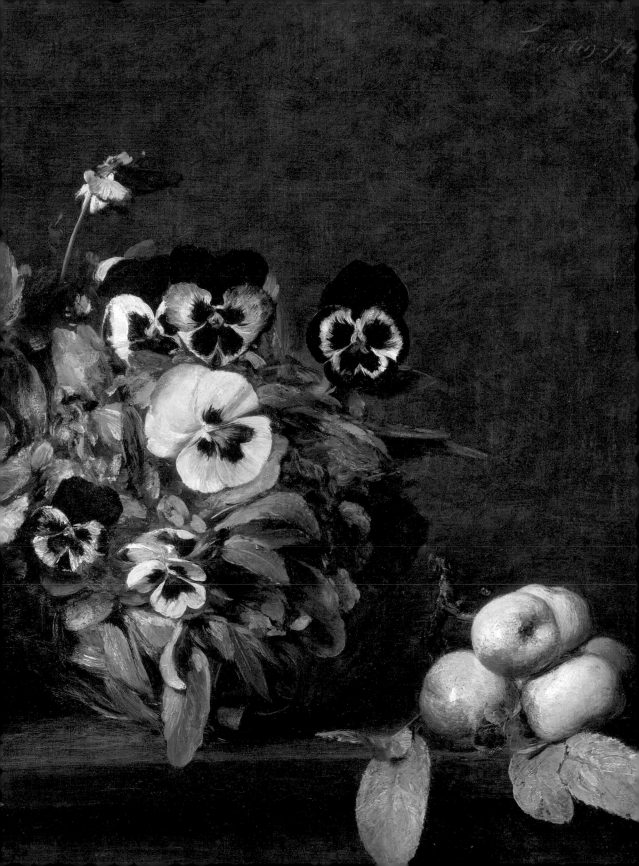

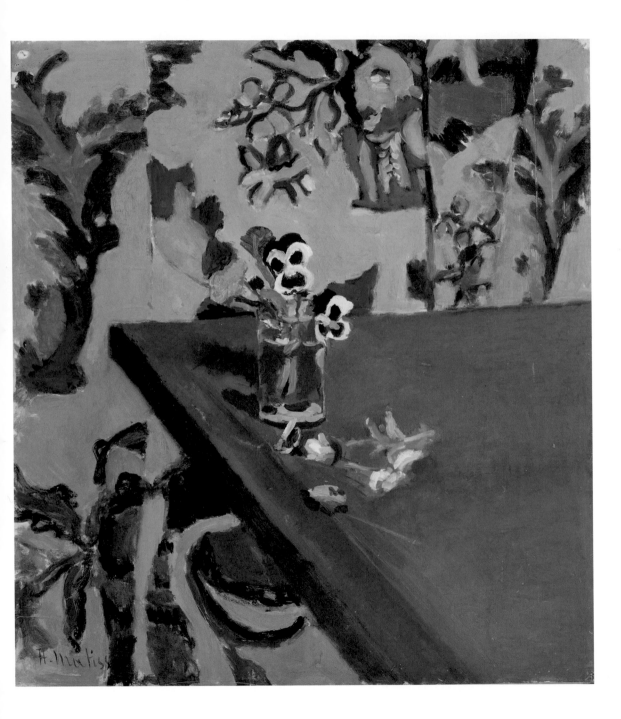

13 *Sunday*

14 *Monday* ●

15 *Tuesday*

16 *Wednesday*

17 *Thursday*

18 *Friday*

19 *Saturday*

MATISSE DELIGHTED IN including patterned textiles, wallpapers, and costumes in his paintings. Here a swath of toile de Jouy in the background nearly overwhelms the picture with its bold, sophisticated floral motif. Yet it's the bright, cheerful pansies that hold our attention, as simple and unassuming as the fabric is assertive.

Pansies

HENRI MATISSE (French, 1869–1954)

Oil on paper mounted on paperboard, 19 ¼ × 17 ¾ in., ca. 1903

Bequest of Joan Whitney Payson, 1975
1976.201.22
© 2019 Succession H. Matisse/Artists Rights Society (ARS), New York

6 *Sunday*

7 *Monday* ◑

8 *Tuesday*

9 *Wednesday*

10 *Thursday* HANUKKAH (BEGINS AT SUNDOWN)

11 *Friday*

12 *Saturday*

Flowering Tree
INDIAN
Opaque watercolor and gold on paper,
10 ³⁄₁₆ × 7 in., ca. 1700
Bequest of Cora Timken Burnett, 1956
57.51.34

AS CHERRY AND plum blossoms are awaited in Japan, and almonds and apples in Provence, in many lands of the Mughal empire—where a brief spring was followed by arid heat and then, likely as not, a season of monsoon—the blossoming of a favorite tree was a moment to be looked for and recorded on paper. These magenta blossoms on curving brown branches stand out against the golden background, set in a decorative niche.

DECEMBER

S	M	T	W	T	F	S
		1	2	3	4	5
6	7	8	9	10	11	12
13	14	15	16	17	18	19
20	21	22	23	24	25	26
27	28	29	30	31		

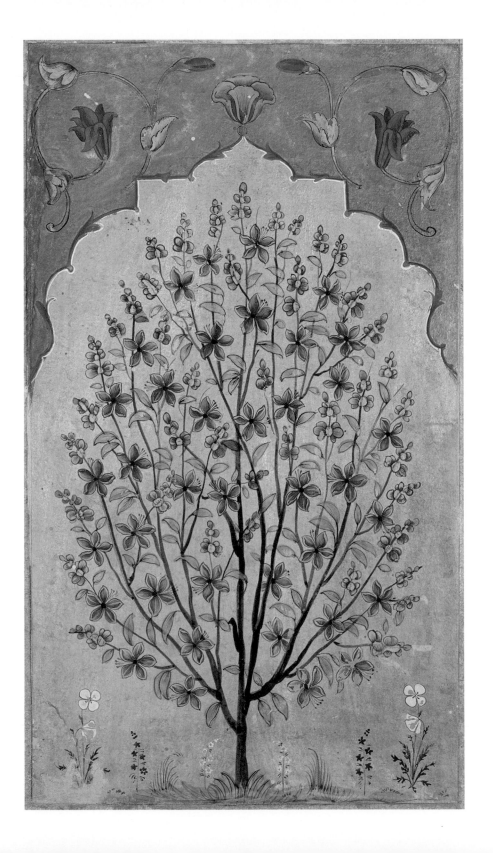

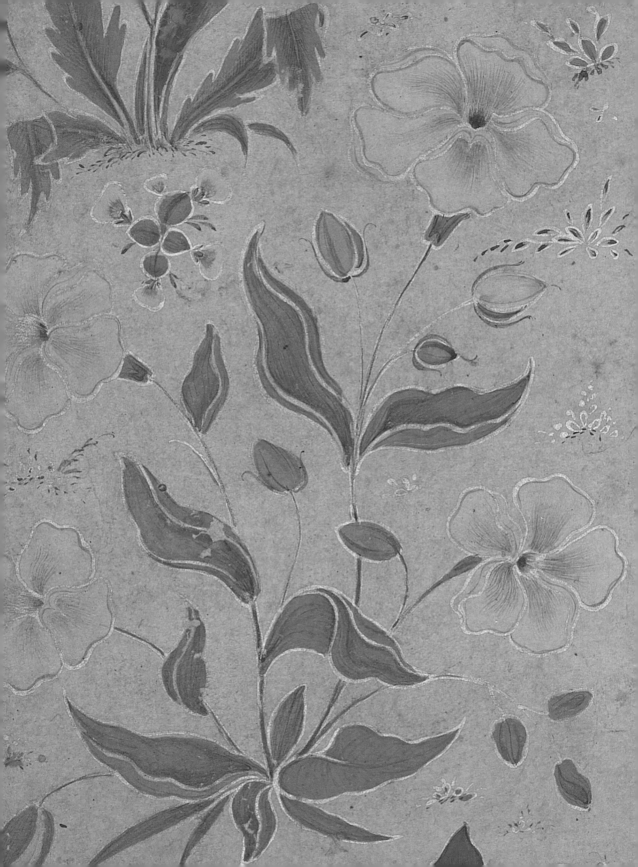

29 *Sunday*

30 *Monday* ST. ANDREW'S DAY (SCT)
○

1 *Tuesday*

2 *Wednesday*

3 *Thursday*

4 *Friday*

5 *Saturday*

DECEMBER

S	M	T	W	T	F	S
		1	2	3	4	5
6	7	8	9	10	11	12
13	14	15	16	17	18	19
20	21	22	23	24	25	26
27	28	29	30	31		

THE BEGUILING BORDER of this leaf from an album assembled for the Mughal emperor Shah Jahan reflects the affinity for flowers of the emperor and his father, Jahangir. It could almost depict a passage Jahangir wrote of Kashmir: "In the fields, there are all kinds of flowers and all sorts of sweet-scented herbs more than can be calculated. In the soul-enchanting spring the hills and plains are filled with blossoms."

Border detail of *Jahangir and His Vizier,* Folio from the *Shah Jahan Album* (detail)
Painting by MANOHAR
(Indian, active ca. 1582–1624)
Ink, opaque watercolor, and gold on paper, 15 ⅜ × 10 ³⁄₁₆ in., ca. 1615
Purchase, Rogers Fund and The Kevorkian Foundation Gift, 1955 55.121.10.23

22 *Sunday*

23 *Monday*

24 *Tuesday*

25 *Wednesday*

26 *Thursday* THANKSGIVING DAY (US)

27 *Friday*

28 *Saturday*

Still Life: Flowers and Fruit (detail)
SEVERIN ROESEN
(American, b. Prussia, 1816–1872?)
Oil on canvas, 40 × 50 ⅜ in., 1850–55
Purchase, Bequest of Charles Allen Munn, by exchange, Fosburgh Fund Inc. and Mr. and Mrs. J. William Middendorf II Gifts, and Henry G. Keasbey Bequest, 1967 67.111

ROESEN CAME TO the United States from a war-torn Europe, and he seems to have appreciated the abundance of the New World, painting a profusion of flowers and fruit in gratitude for the bounty of his new home and as a benediction on what he saw as an American Eden.

NOVEMBER

S	M	T	W	T	F	S
						1
2	3	4	5	6	7	
8	9	10	11	12	13	14
15	16	17	18	19	20	21
22	23	24	25	26	27	28
29	30					

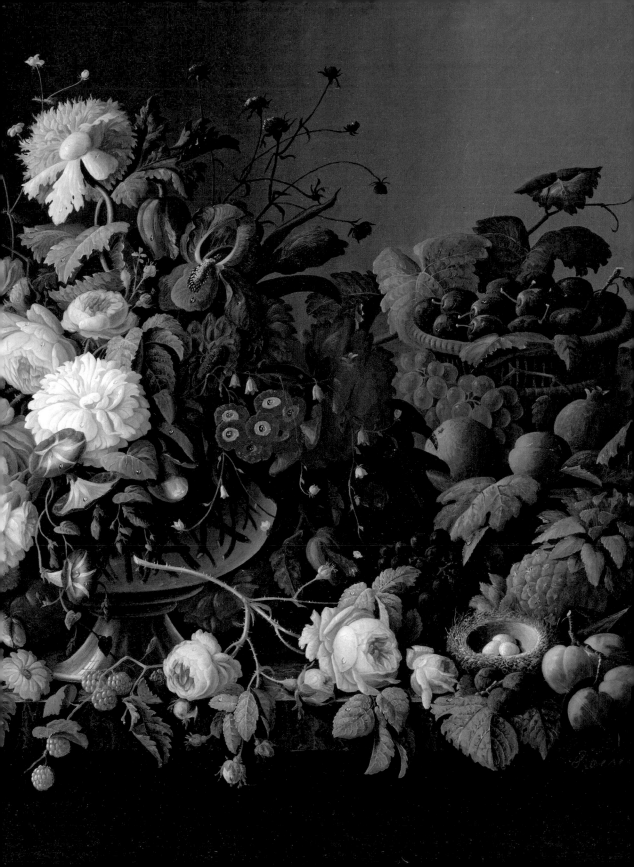

15 *Sunday* ●

16 *Monday*

17 *Tuesday*

18 *Wednesday*

19 *Thursday*

20 *Friday*

21 *Saturday* ◑

NOVEMBER

S	M	T	W	T	F	S
1	2	3	4	5	6	7
8	9	10	11	12	13	14
15	16	17	18	19	20	21
22	23	24	25	26	27	28
29	30					

FLOWERS RARELY APPEAR in Cézanne's still lifes, as they withered too quickly for his methodical process, working out the complex pictorial issues of space, surface, and color that so intrigued him. Perhaps depicting a potted plant rather than cut flowers gave him more time to work. Fruit, though, was another matter. "They like to have their portrait made," he said. "They are there as if to ask your forgiveness for discoloring."

Still Life with Apples and a Pot of Primroses (detail)
PAUL CÉZANNE (French, 1839–1906)
Oil on canvas, 28 ¾ × 36 ⅜ in., ca. 1890
Bequest of Sam A. Lewisohn, 1951 51.112.1

8 *Sunday* REMEMBRANCE SUNDAY (UK)
◑

9 *Monday*

10 *Tuesday*

11 *Wednesday* VETERANS DAY (US)
REMEMBRANCE DAY (CAN)

12 *Thursday*

13 *Friday*

14 *Saturday* DIWALI

*Celia Thaxter's Garden, Isles of
Shoals, Maine* (detail)
CHILDE HASSAM
(American, 1859–1935)
Oil on canvas, 17 ¾ × 21 ½ in., 1890
Anonymous Gift, 1994 1994.567

POPPY SEEDS CAN remain dormant underground for years until conditions are favorable for them to bloom. In World War I, when the battlefields of Flanders were laid bare of vegetation and their soil upturned by bombs, opportunistic poppies sprang forth, becoming the symbol of remembrance for those who lost their lives in the war. The poppies in Hassam's sparkling view of his friend Celia Thaxter's wildflower garden seem more a celebration of life than a commemoration of death.

NOVEMBER

S	M	T	W	T	F	S
1	2	3	4	5	6	7
8	9	10	11	12	13	14
15	16	17	18	19	20	21
22	23	24	25	26	27	28
29	30					

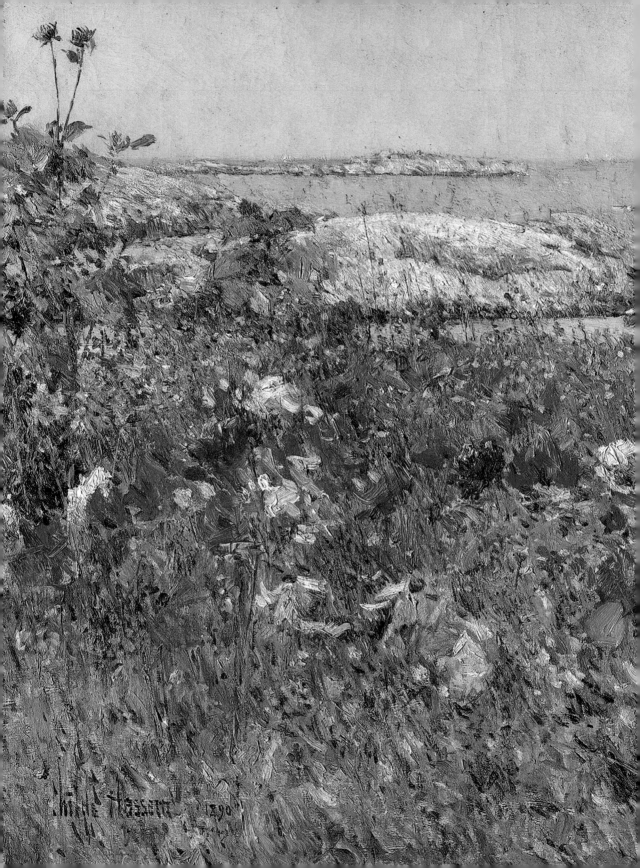

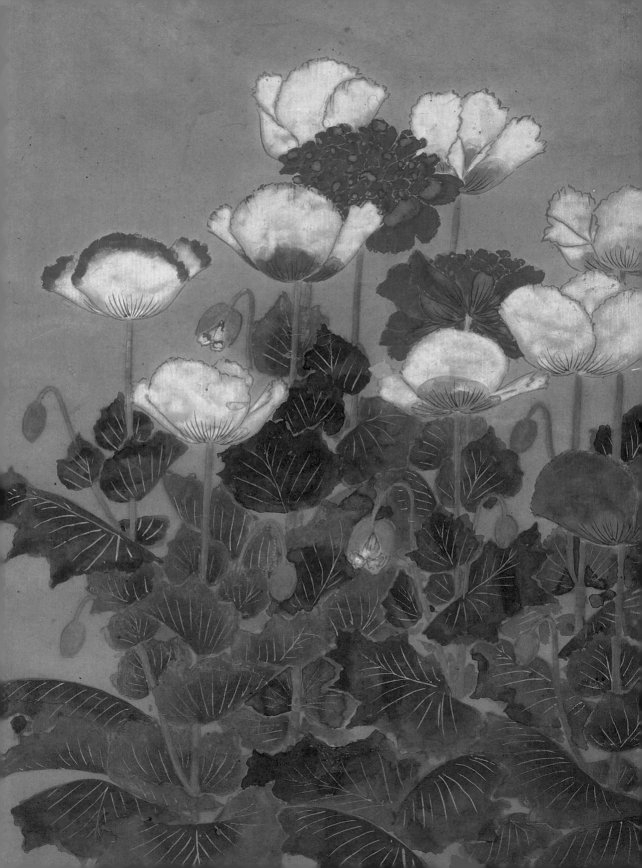

1 *Sunday* DAYLIGHT SAVING TIME ENDS (US, CAN)

2 *Monday*

3 *Tuesday* ELECTION DAY (US)

4 *Wednesday*

5 *Thursday*

6 *Friday*

7 *Saturday*

NOVEMBER

S	M	T	W	T	F	S
1	2	3	4	5	6	7
8	9	10	11	12	13	14
15	16	17	18	19	20	21
22	23	24	25	26	27	28
29	30					

IN THIS JAPANESE scroll, red and white poppies bloom on a golden ground in stages from bud to blossom to fully blown. Depicting the flowers in their different phases could be symbolic of the passage of time and even of the stages of human life; the tightly closed buds are a reminder that nature is cyclical, and spring will come again.

Poppies (detail)

Attributed to KITAGAWA SŌSETSU (Japanese, active 1639–50)

Hanging scroll; color and gold on paper, 34 ¼ × 14 ⅝ in., mid-17th century

H. O. Havemeyer Collection, Bequest of Mrs. H. O. Havemeyer, 1929 29.100.524

25 *Sunday* SUMMER TIME ENDS (UK, IRL)

26 *Monday* BANK HOLIDAY (IRL)
 LABOUR DAY (NZ)

27 *Tuesday*

28 *Wednesday*

29 *Thursday*

30 *Friday*

31 *Saturday* HALLOWEEN
 ○

The Brioche (detail)
ÉDOUARD MANET
(French, 1832–1883)
Oil on canvas, 25 ⅝ × 31 ⅞ in., 1870
Gift and Bequest of David and Peggy
Rockefeller, 1991, 2017 1991.287

WITHOUT A DOUBT, flowers and fruit are constant companions in still life painting. And while the fruit may sometimes rest or roll directly on a table, the flowers are customarily in vases or other containers. In Manet's elegant image, the plums, peaches, and grapes take their usual positions, but the luscious, pink-tinged rose emerges directly from a golden-brown brioche.

OCTOBER

S	M	T	W	T	F	S
				1	2	3
4	5	6	7	8	9	10
11	12	13	14	15	16	17
18	19	20	21	22	23	24
25	26	27	28	29	30	31

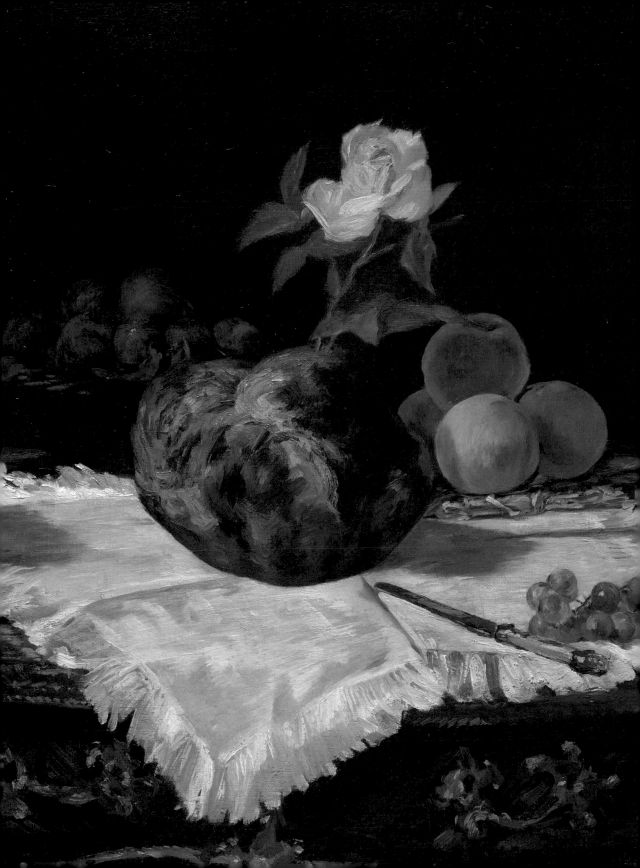

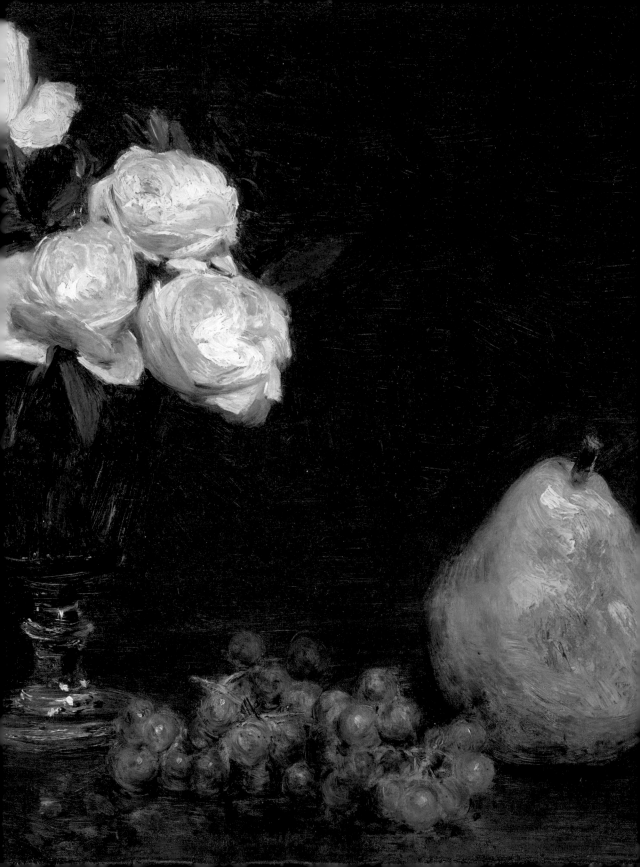

18 *Sunday*

19 *Monday*

20 *Tuesday*

21 *Wednesday*

22 *Thursday*

23 *Friday* ◐

24 *Saturday*

OCTOBER

S	M	T	W	T	F	S
				1	2	3
4	5	6	7	8	9	10
11	12	13	14	15	16	17
18	19	20	21	22	23	24
25	26	27	28	29	30	31

FOR MORE THAN 30 years, Fantin-Latour supplied small and beautiful flower pictures to a largely English clientele who particularly loved roses. He became so closely associated with the flower that a variety with pale pink blossoms was named after him. These roses are painted with such care and attention that, as a later artist said of Fantin-Latour's subjects, each one "is itself, and not another of the same species."

Still Life with Roses and Fruit (detail)
HENRI FANTIN-LATOUR
(French, 1836–1904)
Oil on canvas, 13 ⅝ × 16 ⅜ in., 1863
Bequest of Alice A. Hay, 1987 1987.119

11 *Sunday*

12 *Monday*

<div align="right">COLUMBUS DAY (US)
THANKSGIVING DAY (CAN)</div>

13 *Tuesday*

14 *Wednesday*

15 *Thursday*

16 *Friday* ●

17 *Saturday*

Mauve Primulas on a Table
(detail)
WILLIAM NICHOLSON
(British, 1872–1949)
Oil on wood, 23 ¾ × 16 ¾ in., 1928
Bequest of Mary Cushing Fosburgh, 1978
1979.135.15
© Desmond Banks

ON CLOSER INSPECTION, what appears to be a simple picture of garden flowers casually stuck in a vase or drinking glass is revealed to be a more complex motif. The tilted tabletop almost fills the picture plane, the light picks out the texture of the tablecloth, and ambiguous shadows almost shape an additional container for the bouquet. Nicholson's son, the artist Ben Nicholson, said his father's still lifes were filled with "poetic spirit."

OCTOBER

S	M	T	W	T	F	S
				1	2	3
4	5	6	7	8	9	10
11	12	13	14	15	16	17
18	19	20	21	22	23	24
25	26	27	28	29	30	31

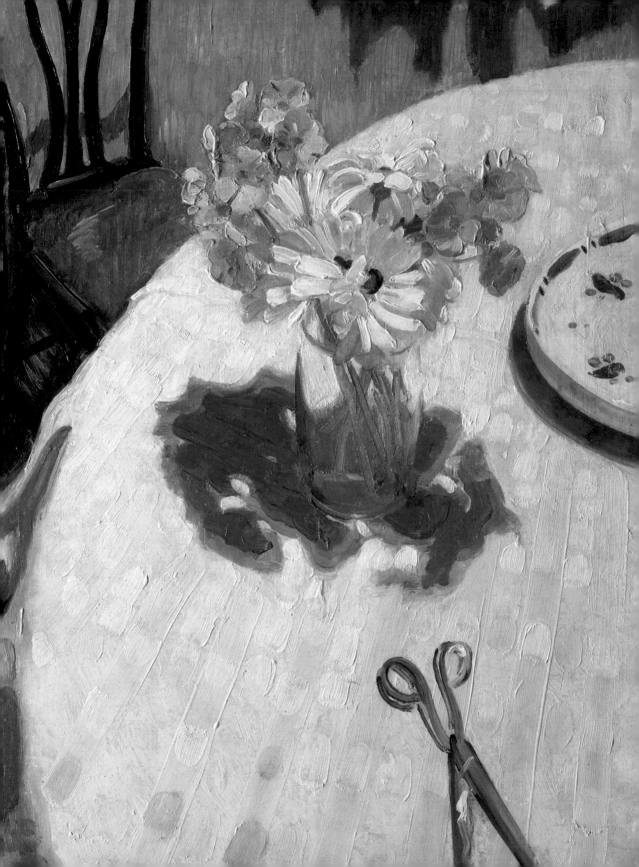

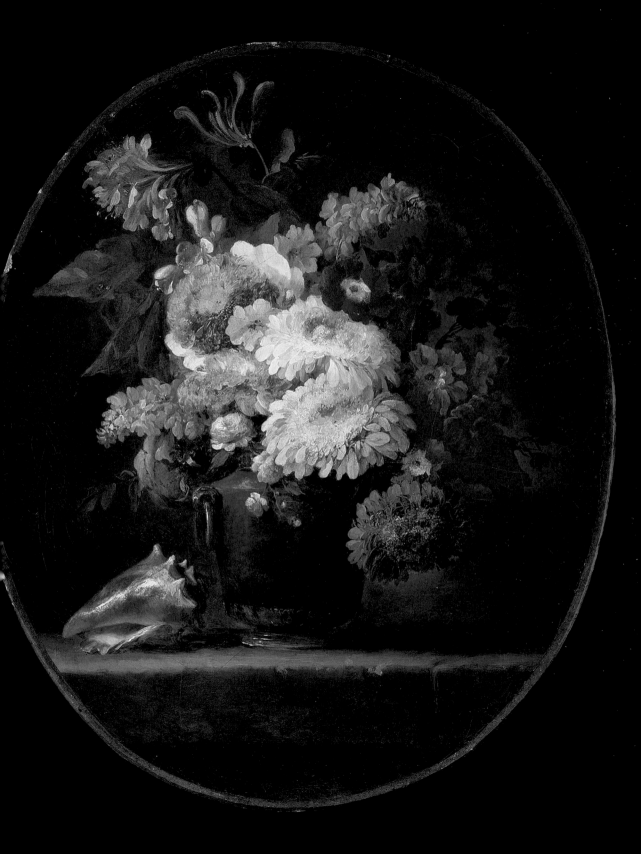

4 *Sunday*

5 *Monday*

6 *Tuesday*

7 *Wednesday*

8 *Thursday*

9 *Friday*

10 *Saturday*

OCTOBER

S	M	T	W	T	F	S
				1	2	3
4	5	6	7	8	9	10
11	12	13	14	15	16	17
18	19	20	21	22	23	24
25	26	27	28	29	30	31

STILL-LIFE PAINTING WAS on the bottom rung of the hierarchy of subjects for French academic painting, but Vallayer-Coster was nevertheless successful, admired by critics and patrons, including Marie Antoinette (before the Revolution) and Empress Josephine (after). Here, the flowers, including anemones and marguerites, spill from an elegant vase, with accents of light on the porcelain, the gilt, and the pearly shell.

Vase of Flowers and Conch Shell
ANNE VALLAYER-COSTER
(French, 1744–1818)
Oil on canvas, 19 ¾ × 15 in., 1780
Gift of J. Pierpont Morgan, 1906 07.225.504

27 *Sunday* YOM KIPPUR (BEGINS AT SUNDOWN)

28 *Monday*

29 *Tuesday*

30 *Wednesday*

1 *Thursday* ○

2 *Friday*

3 *Saturday*

Persimmons on a Plate (detail)
KUBO SHUNMAN
(Japanese, 1757–1820)
Polychrome woodblock print
(surimono); ink and color on paper,
8 ⅛ × 7 ⅟₁₆ in., 19th century
H. O. Havemeyer Collection, Bequest of Mrs.
H. O. Havemeyer, 1929 JP2120

PERSIMMONS ARE AN autumn treat in Japan. The more oblong variety are very astringent and need to be eaten either very ripe or dried; in some places, you can see them peeled and hanging on long strings to dry. The persimmons here look like the rounder, sweet variety. With their bright, festive color and delectable flavor, they are also a traditional New Year's delicacy.

OCTOBER

S	M	T	W	T	F	S
				1	2	3
4	5	6	7	8	9	10
11	12	13	14	15	16	17
18	19	20	21	22	23	24
25	26	27	28	29	30	31

望月影成

いさよひと名をよとめ
井の中よりもの
末の海よりかきみ
名をとり夏くも

一さそ明けとむ
よろふに掛もみくき
恵のゆうへに

北窓梅好

諸句みろの名の
名よりもろ名の名の
樹を高られるみ

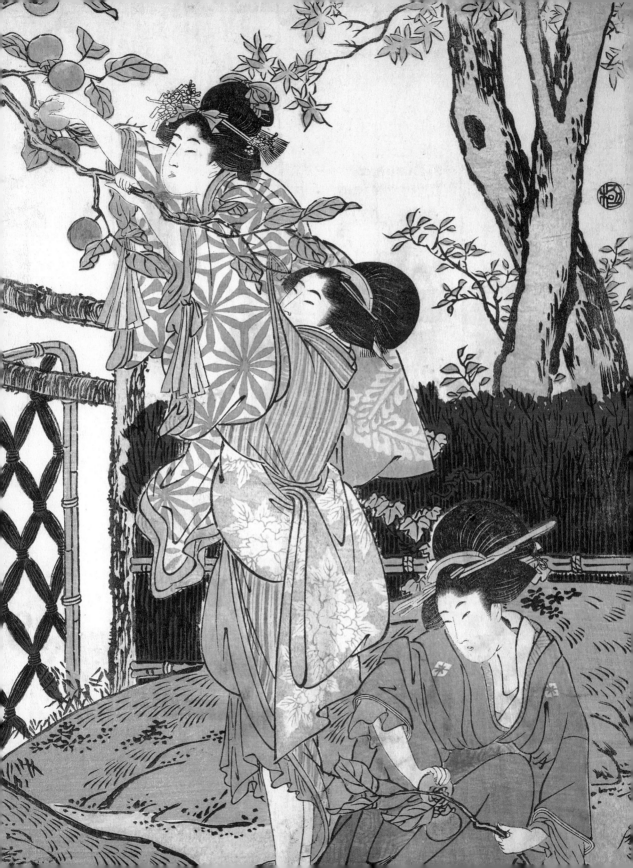

20 *Sunday*

21 *Monday*

22 *Tuesday* AUTUMNAL EQUINOX

23 *Wednesday* ◑

24 *Thursday*

25 *Friday*

26 *Saturday*

SEPTEMBER

S	M	T	W	T	F	S
		1	2	3	4	5
6	7	8	9	10	11	12
13	14	15	16	17	18	19
20	21	22	23	24	25	26
27	28	29	30			

THE JAPANESE, EVER attuned to the changing seasons, designated fruits for different times of year. Persimmons, whose colors suggest the gold and orange foliage of fall, are associated with autumn. These women are approaching their task with relish, one hoisting another up to reach the higher hanging fruit. Utamaro was a specialist in depicting women in all kinds of activities; here, even their patterned kimonos echo the colors of the tawny fruits.

Picking Persimmons (detail)
KITAGAWA UTAMARO
(Japanese, ca. 1754–1806)
Triptych of polychrome woodblock prints; ink and color on paper, 15 × 30 in., ca. 1802–4
Gift of Estate of Samuel Isham, 1914 JP994

13 *Sunday*

14 *Monday*

15 *Tuesday*

16 *Wednesday*

17 *Thursday* ●

18 *Friday* ROSH HASHANAH (BEGINS AT SUNDOWN)

19 *Saturday*

Apples and Grapes (detail)
CLAUDE MONET
(French, 1840–1926)
Oil on canvas, 26 ⅝ × 35 ¼ in., 1879–80
Gift of Henry R. Luce, 1957 57.183

MONET'S CANVAS IS patently a painting of fruit, but it is also a painting about light—the contrast between the shadows cast on the background and much of the basket with the light that skims across tops of the grapes and the bumps on the apples. Like the snow in Monet's winter landscapes, the tablecloth is not really white—it seems almost to reflect the dusky purples and green golds of the fruit.

SEPTEMBER

S	M	T	W	T	F	S
		1	2	3	4	5
6	7	8	9	10	11	12
13	14	15	16	17	18	19
20	21	22	23	24	25	26
27	28	29	30			

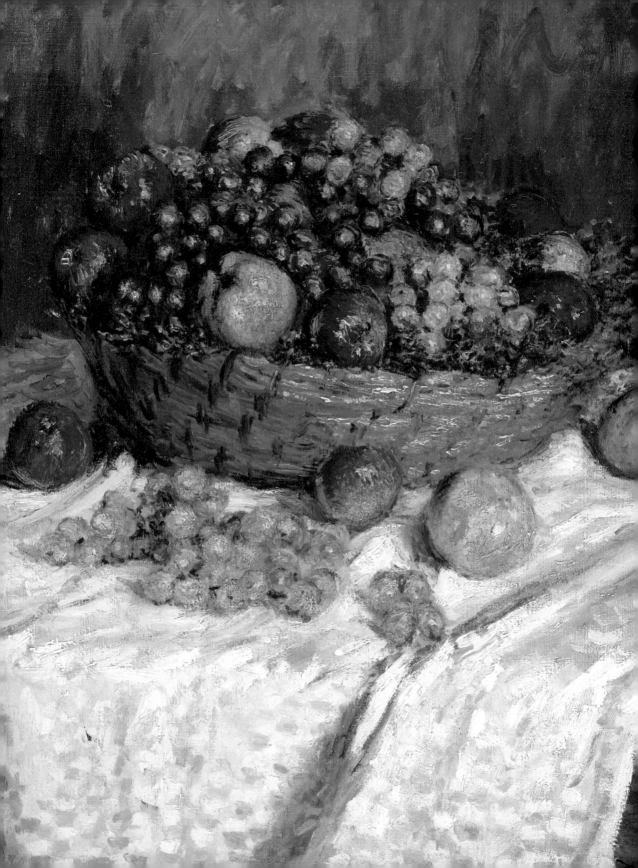

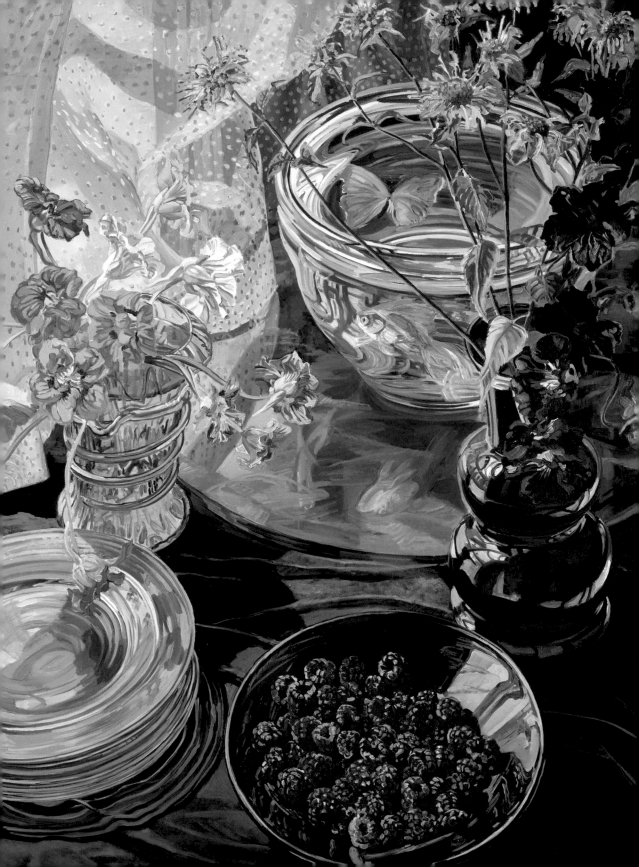

6 *Sunday*	FATHER'S DAY (AUS, NZ)
7 *Monday*	LABOR DAY (US, CAN)
8 *Tuesday*	
9 *Wednesday*	
10 *Thursday*	◐
11 *Friday*	
12 *Saturday*	

SEPTEMBER

S	M	T	W	T	F	S
		1	2	3	4	5
6	7	8	9	10	11	12
13	14	15	16	17	18	19
20	21	22	23	24	25	26
27	28	29	30			

IT MAY LOOK like Fish has decided to paint everything piled on her kitchen table, but her carefully composed still life is a vehicle for depictions of light—the way it filters through the translucent curtain, or catches the tip of a flower petal, or bounces off the bowl with the raspberries. The many types and layers of glass, too, reflect or absorb the sunlight, creating visual complexities: Is the butterfly real or is it a decoration on the fishbowl?

Raspberries and Goldfish (detail)

JANET FISH (American, b. 1938)

Oil on linen with acrylic gesso ground, 72 × 64 in., 1981

Purchase, The Cape Branch Foundation and Lila Acheson Wallace Gifts, 1983 1983.171
© Janet Fish

30 *Sunday*

31 *Monday* SUMMER BANK HOLIDAY (UK, EXCEPT SCT)

1 *Tuesday*

2 *Wednesday* ○

3 *Thursday*

4 *Friday*

5 *Saturday*

Peach Blossoms at My Window
from *Wilderness Colors* (detail)
SHITAO (ZHU RUOJI)
(Chinese, 1642–1707)
One from an album of twelve paintings;
ink and color on paper, 10 ⅞ × 9 ½ in.,
ca. 1700
The Sackler Fund, 1972 1972.122a–l

THE AGING SHITAO retreated from life to
devote himself to art and contemplation. The
poem that accompanies this image expresses the
poignancy of the artist reflecting on his circum-
stances: "Spring breeze and gentle rain come to
the window of my mountain lodge; / Even now,
I paint peach blossoms in their colorful attire. / I
laugh at myself that in spite of old age I have not
learned to live with leisure, / And must still play
with my brush to pass the time."

SEPTEMBER

S	M	T	W	T	F	S
		1	2	3	4	5
6	7	8	9	10	11	12
13	14	15	16	17	18	19
20	21	22	23	24	25	26
27	28	29	30			

春風細雨到山隈
卻寬桃花似醉來
老去未閒空自笑
西源枕尋過時芳

若屁

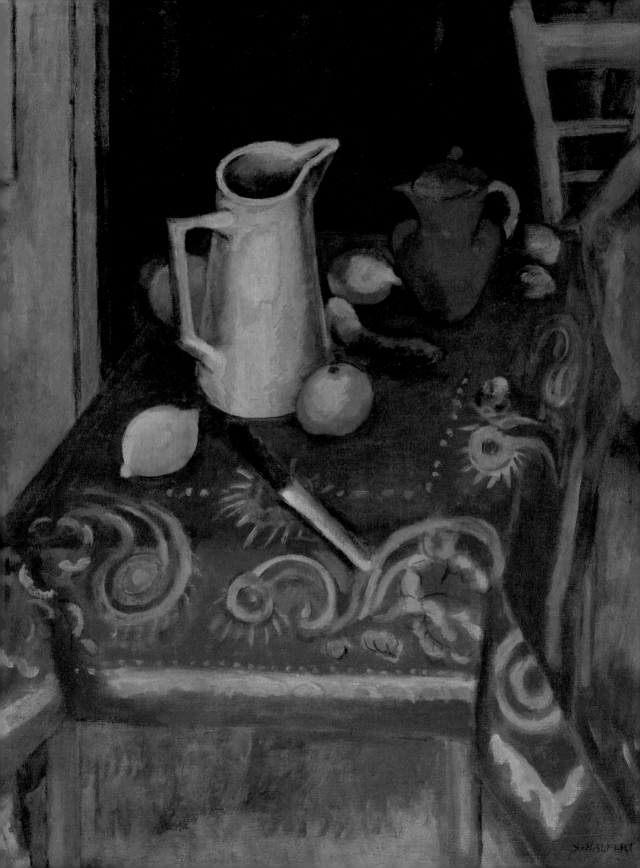

23 *Sunday*

24 *Monday*

25 *Tuesday* ◑

26 *Wednesday*

27 *Thursday*

28 *Friday*

29 *Saturday*

AUGUST						
S	M	T	W	T	F	S
						1
2	3	4	5	6	7	8
9	10	11	12	13	14	15
16	17	18	19	20	21	22
23	24	25	26	27	28	29
30	31					

ONE OF THE first Americans to be influenced by European modern art—he went to Paris as a teenager—Halpert absorbed and responded to the innovations of Post-Impressionism, including the coloristic inventiveness of Fauvism. This tabletop, painted in Portugal, displays pitchers and fruit that Cézanne might have used, but Halpert seems less interested in defining their forms than in attracting the eye to the cheerful color and pleasing pattern of the red tablecloth.

The Red Tablecloth (detail)
SAMUEL HALPERT
(American, b. Russia, 1884–1930)
Oil on canvas, 30 ⅛ × 25 ⅛ in., 1915
Anonymous Gift, 1994 1994.394

16 *Sunday*

17 *Monday*

18 *Tuesday* ●

19 *Wednesday*

20 *Thursday*

21 *Friday*

22 *Saturday*

Lilacs in a Window (detail)
MARY CASSATT
(American, 1844–1926)
Oil on canvas, 24 3/16 × 20 1/8 in.,
ca. 1880–83
Partial and Promised Gift of Mr. and Mrs.
Douglas Dillon, 1997 1997.207

CASSATT, OF COURSE, is best known for her paintings and prints of women and children. Though she rarely painted still lifes, some of her images of domestic life include vases of flowers in the background or dainty dishes of fruit ready to be consumed. Here, the lilacs are placed in the window of a greenhouse—possibly because their fragrance, though sweet, can sometimes be overpowering.

AUGUST

S	M	T	W	T	F	S
						1
2	3	4	5	6	7	8
9	10	11	12	13	14	15
16	17	18	19	20	21	22
23	24	25	26	27	28	29
30	31					

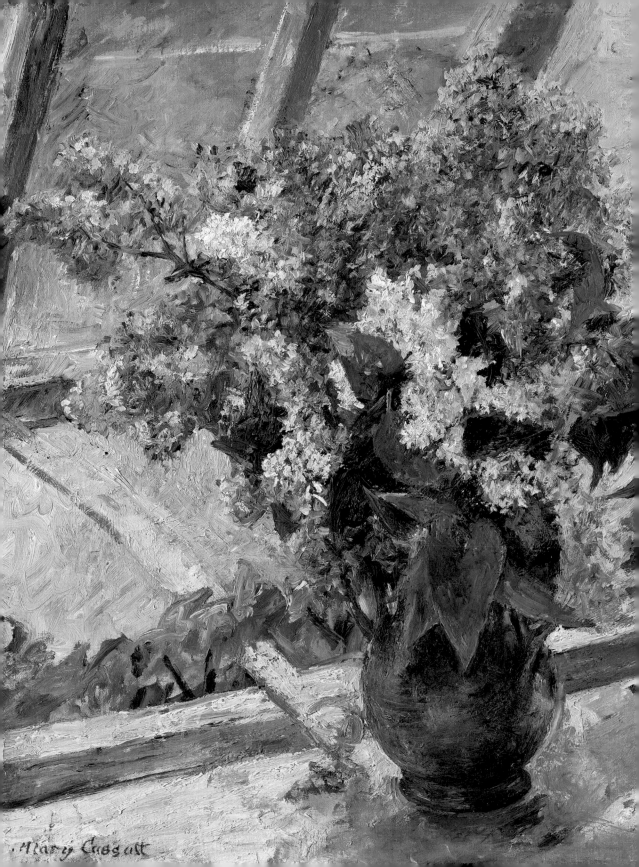

Mary Cassatt

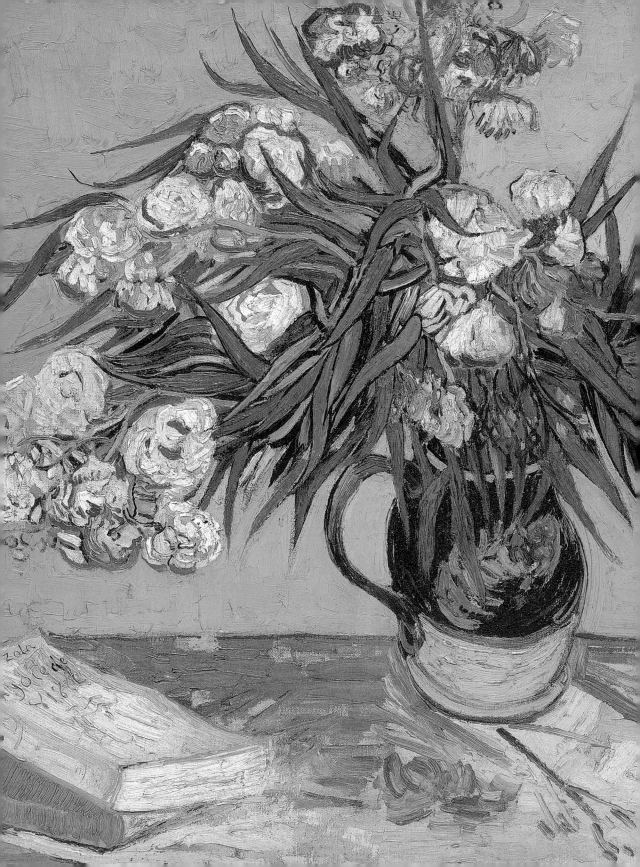

9 *Sunday*

10 *Monday*

11 *Tuesday* ◑

12 *Wednesday*

13 *Thursday*

14 *Friday*

15 *Saturday*

AUGUST						
S	M	T	W	T	F	S
						1
2	3	4	5	6	7	8
9	10	11	12	13	14	15
16	17	18	19	20	21	22
23	24	25	26	27	28	29
30	31					

FOR VAN GOGH, oleanders were life-affirming, exuberant symbols of regeneration. And "How beautiful yellow is," he said—for him it was the color of sun, light, health, and cheerfulness. He underlined the joyous mood of this painting by placing on the table a copy of Emile Zola's book *La joie de vivre*. Ironically, oleanders are poisonous if consumed.

Oleanders (detail)
VINCENT VAN GOGH
(Dutch, 1853–1890)
Oil on canvas, 23 ¾ × 29 in., 1888
Gift of Mr. and Mrs. John L. Loeb, 1962 62.24

2 *Sunday*

3 *Monday*

<div align="right">CIVIC HOLIDAY (CAN)
SUMMER BANK HOLIDAY (SCT, IRL)
○</div>

4 *Tuesday*

5 *Wednesday*

6 *Thursday*

7 *Friday*

8 *Saturday*

Fruit or Pomegranate (detail)
WILLIAM MORRIS (British, 1834–1896)
Made by MORRIS & COMPANY
Block-printed wallpaper,
27 1⁄16 × 21 5⁄8 in., designed 1865–66
Purchase, Edward C. Moore Jr. Gift, 1923
23.163.4g

MORRIS PRODUCED DOZENS of wallpaper designs, all of them centering on plant-based motifs. Even as a child, he spent time wandering the countryside, and his motifs always spring from a close observation of nature. But he disdained images of "sham-real boughs and flowers," and in his work, natural forms are transmuted into stylized patterns, like this one with its nubbly limes and pomegranates bursting with seeds.

AUGUST

S	M	T	W	T	F	S
						1
2	3	4	5	6	7	8
9	10	11	12	13	14	15
16	17	18	19	20	21	22
23	24	25	26	27	28	29
30	31					

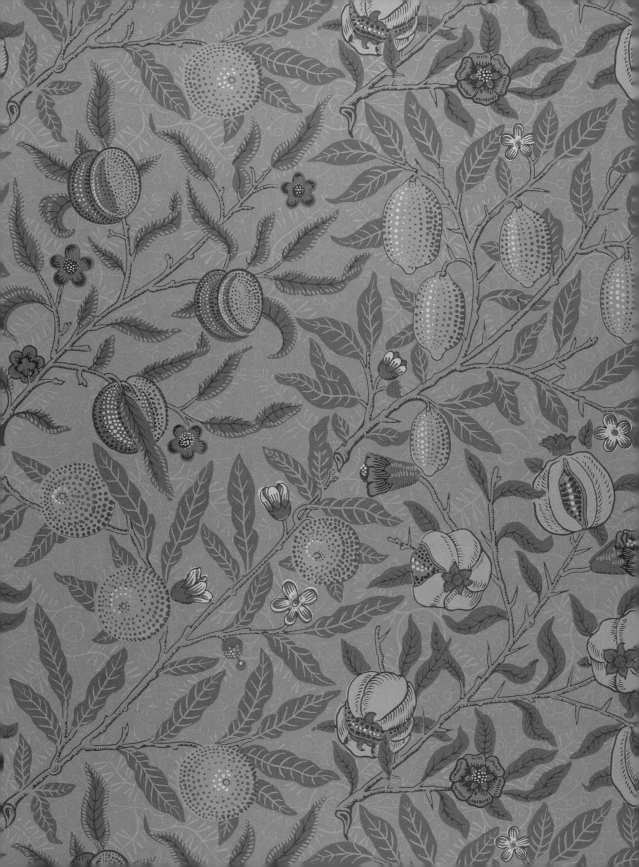

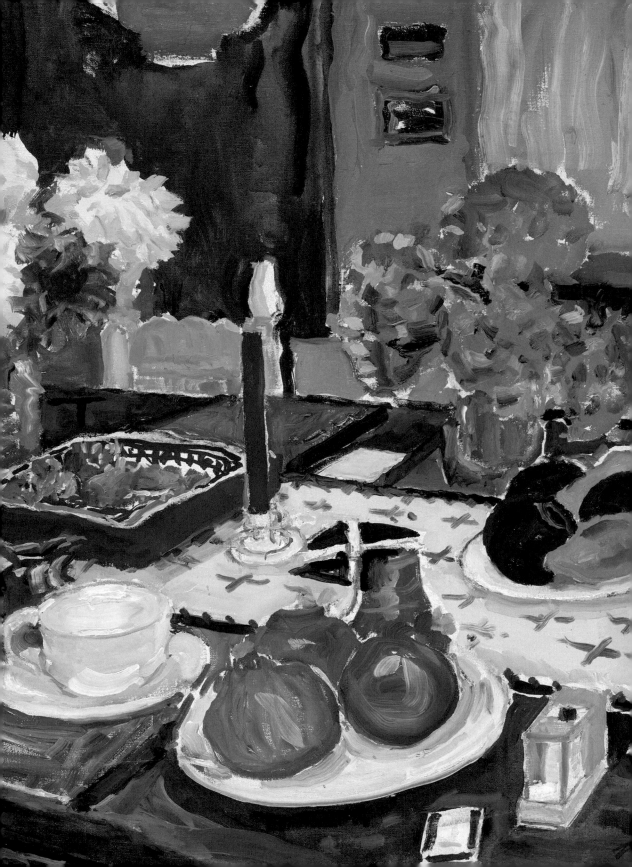

26 *Sunday*

27 *Monday* ◑

28 *Tuesday*

29 *Wednesday*

30 *Thursday* EID AL-ADHA (BEGINS AT SUNDOWN)

31 *Friday*

1 *Saturday*

AUGUST						
S	M	T	W	T	F	S
						1
2	3	4	5	6	7	8
9	10	11	12	13	14	15
16	17	18	19	20	21	22
23	24	25	26	27	28	29
30	31					

BLAINE'S FLUID BRUSHSTROKES energize all the shapes on her table—the red orbs of the pomegranates, the intermingled apples and lemons, and particularly the fluffy, pillowy dahlias. Yet everything is organized in an almost grid-like composition by the rhythm of rectangles: the table itself, the blue placemats, the chocolate cake in the center, and the colored panels in the background. Although known for painting from nature, Blaine said, "It all goes back to Mondrian."

Big Table with Pomegranates
(detail)
NELL BLAINE (American, 1922–1996)
Oil on canvas, 22 × 26 in., 1978
Gift of Arthur W. Cohen, 1985 1985.36.1

19 *Sunday*

20 *Monday* ●

21 *Tuesday*

22 *Wednesday*

23 *Thursday*

24 *Friday*

25 *Saturday*

Bouquet of Sunflowers (detail)
CLAUDE MONET (French, 1840–1926)
Oil on canvas, 39 ¾ × 32 in., 1881
H. O. Havemeyer Collection, Bequest of Mrs.
H. O. Havemeyer, 1929 29.100.107

VAN GOGH, NO slouch himself when it came to painting sunflowers, wrote to his brother Theo: "Gauguin was telling me the other day—that he'd seen a painting by Claude Monet of sunflowers in a large Japanese vase, very fine. But—he likes mine better. I'm not of that opinion."

JULY

S	M	T	W	T	F	S
			1	2	3	4
5	6	7	8	9	10	11
12	13	14	15	16	17	18
19	20	21	22	23	24	25
26	27	28	29	30	31	

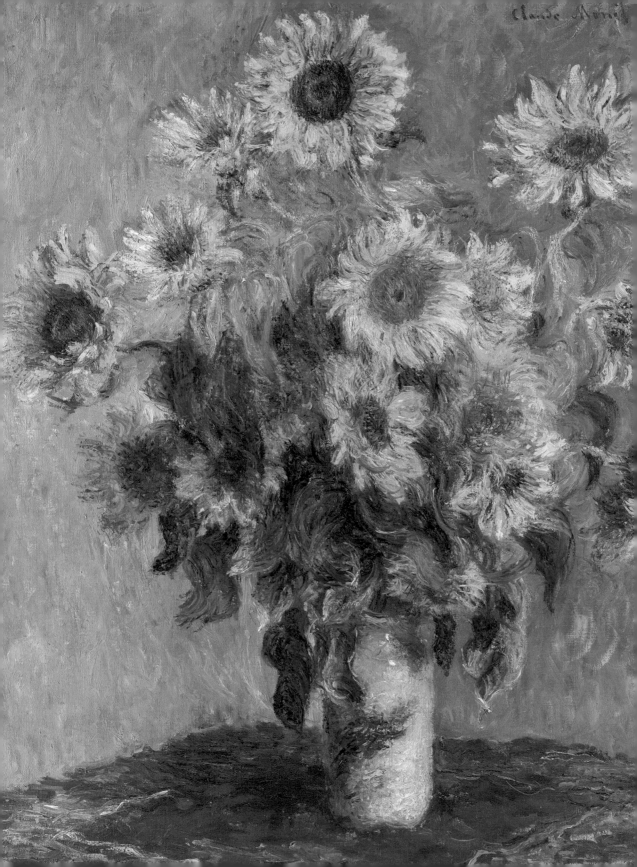

12 *Sunday* ORANGEMEN'S DAY (N. IRL)

◐

13 *Monday* ORANGEMEN'S DAY OBSERVED (N. IRL)

14 *Tuesday*

15 *Wednesday*

16 *Thursday*

17 *Friday*

18 *Saturday*

JULY						
S	M	T	W	T	F	S
			1	2	3	4
5	6	7	8	9	10	11
12	13	14	15	16	17	18
19	20	21	22	23	24	25
26	27	28	29	30	31	

KAUFFER WAS OBLIGED to leave his art studies in Paris when World War I began. On his way home to the United States, he stopped in London and decided to stay, fortuitously, for he caught the attention of a manager for the London Underground and began a successful career creating eye-catching posters for them and others. His style evolved to include bold colors and geometric shapes, like those in these expressive, angular sunflowers.

Sunflowers
EDWARD MCKNIGHT KAUFFER
(American, 1890–1954)
Oil on canvas, 36 × 24 in., 1921
Purchase, The Mrs. Claus von Bulow Fund
Gift, 1987 1987.5

5 *Sunday* ○

6 *Monday*

7 *Tuesday*

8 *Wednesday*

9 *Thursday*

10 *Friday*

11 *Saturday*

The Flowering Orchard (detail)
VINCENT VAN GOGH
(Dutch, 1853–1890)
Oil on canvas, 28 ½ × 21 in., 1888
The Mr. and Mrs. Henry Ittleson Jr. Purchase
Fund, 1956 56.13

SOON AFTER ARRIVING in Arles after a gray, gloomy Parisian winter, Van Gogh began to paint the flowering fruit trees of Provence, hoping to realize an "outstanding gaiety" in a group of fourteen canvases. It was not just the blossoming branches that compelled him; here he has also included bright flowers sprinkled in the grass, not unlike the meadows beloved in the Middle Ages.

JULY

S	M	T	W	T	F	S	
				1	2	3	4
5	6	7	8	9	10	11	
12	13	14	15	16	17	18	
19	20	21	22	23	24	25	
26	27	28	29	30	31		

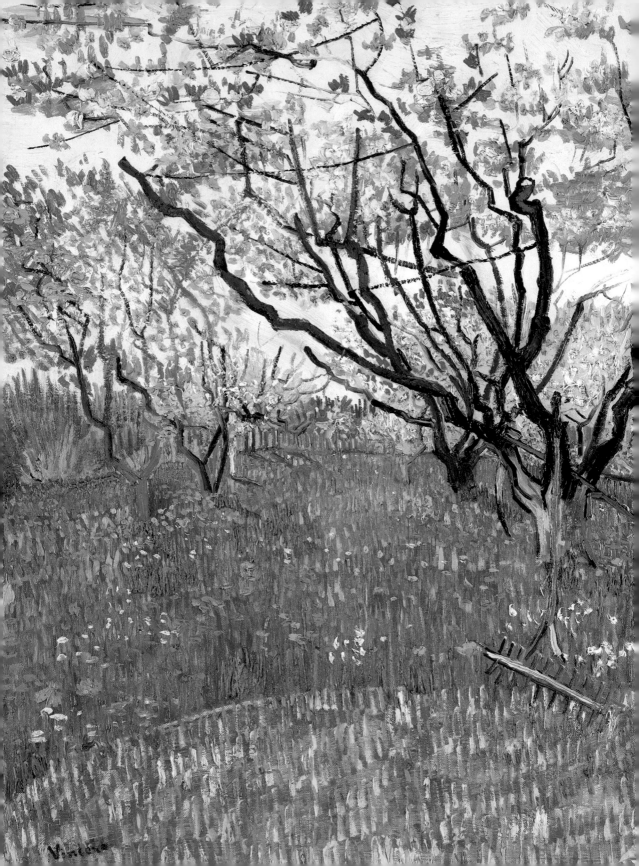

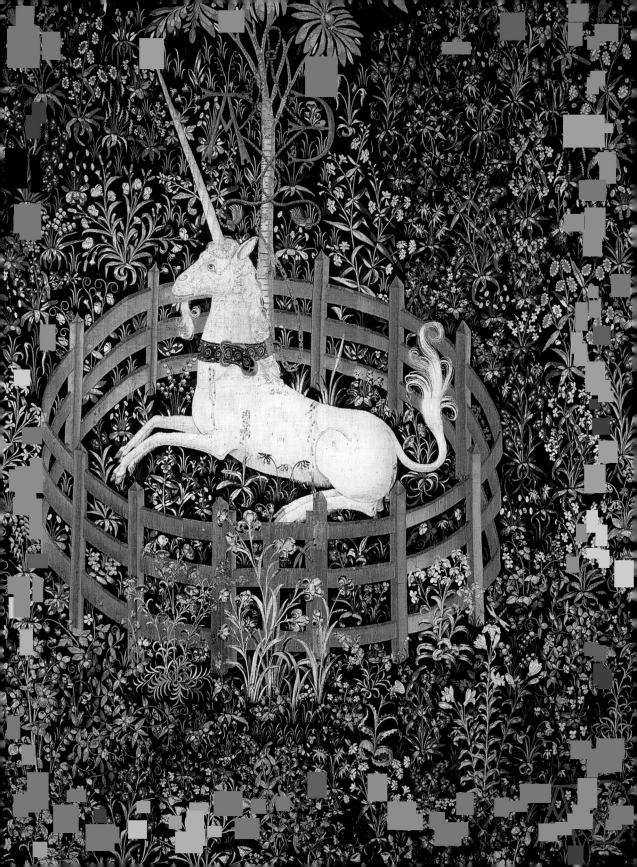

28 *Sunday* ◗

29 *Monday*

30 *Tuesday*

1 *Wednesday*　　　　　　　　　CANADA DAY (CAN)

2 *Thursday*

3 *Friday*　　　　　　　　INDEPENDENCE DAY OBSERVED (US)

4 *Saturday*　　　　　　　　　INDEPENDENCE DAY (US)

			JULY			
S	M	T	W	T	F	S
			1	2	3	4
5	6	7	8	9	10	11
12	13	14	15	16	17	18
19	20	21	22	23	24	25
26	27	28	29	30	31	

A PLETHORA OF plants cover nearly every inch of this painstakingly woven millefleur, or "thousand flower," tapestry. Flowers of different seasons bloom together in an idealized garden—a "flowery mede" beloved by people of the Middle Ages—much like the one described by Boccaccio in *The Decameron*: "What seemed more delightful than anything else, was a plot of ground like a meadow; the grass of a deep green, spangled with a thousand different flowers."

The Unicorn in Captivity
from the Unicorn Tapestries (detail)
SOUTH NETHERLANDISH
Wool warp with wool, silk, silver, and gilt wefts, 12 ft. ⅞ in. × 8 ft. 3 in., 1495–1505
Gift of John D. Rockefeller Jr., 1937 37.80.6

21 *Sunday*

FATHER'S DAY (US, CAN, UK)

●

22 *Monday*

23 *Tuesday*

24 *Wednesday*

25 *Thursday*

26 *Friday*

27 *Saturday*

Dish of Fruit and Peach
Blossoms
CHINESE, Qing dynasty (1644–1911)
Jade (jadeite) and various stones,
amber, glass, bone, and feathers,
18th–19th century
Gift of Heber R. Bishop, 1902 02.18.746

THE NAMES OF nature's most ancient and enduring products—minerals—are often used to describe her most fresh and fugitive—fruits and flowers. We talk of ruby-colored berries, amethyst petals, emerald leaves. Here the peaches, peach blossoms, and lychees are actually made of semiprecious stones, and the permanence of the material underscores the symbolism of longevity—peaches—and fertility and good fortune—lychees.

JUNE

S	M	T	W	T	F	S
	1	2	3	4	5	6
7	8	9	10	11	12	13
14	15	16	17	18	19	20
21	22	23	24	25	26	27
28	29	30				

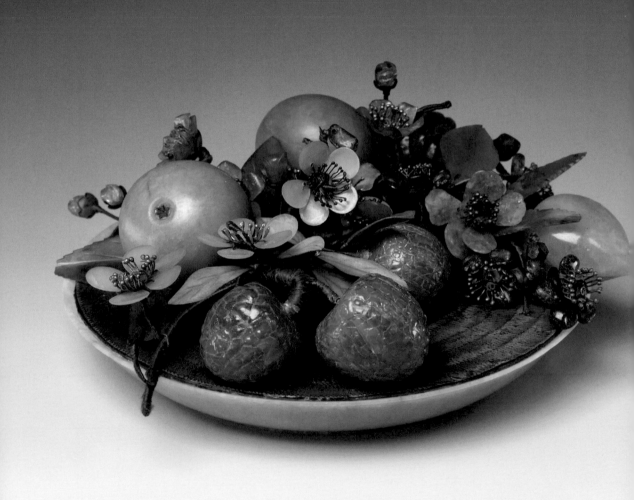

14 *Sunday*

FLAG DAY (US)

15 *Monday*

16 *Tuesday*

17 *Wednesday*

18 *Thursday*

19 *Friday*

20 *Saturday*

SUMMER SOLSTICE

JUNE

S	M	T	W	T	F	S
	1	2	3	4	5	6
7	8	9	10	11	12	13
14	15	16	17	18	19	20
21	22	23	24	25	26	27
28	29	30				

RENOIR DEVISED THIS still life soon after a visit to Cézanne in Provence, which may be where he encountered the spiny prickly pears. The fruit is disposed in a Cézanne-like arrangement, but the bouquet of autumn flowers is pure Renoir. "I just let my brain rest when I paint flowers," he said. "I establish the tones, I study the values carefully, without worrying about losing the picture."

Still Life with Flowers and Prickly Pears (detail)
AUGUSTE RENOIR
(French, 1841–1919)
Oil on canvas, 28 ⅞ × 23 ⅜ in., ca. 1885
Bequest of Catherine Vance Gaisman, 2010
2010.454

7 *Sunday*

8 *Monday*

9 *Tuesday*

10 *Wednesday*

11 *Thursday*

12 *Friday*

13 *Saturday* ◑

Magnolias and Irises (detail)
LOUIS COMFORT TIFFANY
(American, 1848–1933)
Made by TIFFANY STUDIOS
(American, 1902–1932)

Leaded Favrile glass, 60 ¼ × 42 in.,
ca. 1908

Anonymous Gift, in memory of Mr. and Mrs.
A. B. Frank, 1981 1981.159

IRISES ARE NAMED for the Greek goddess of the rainbow, an appropriate etymology for the many-hued flowers with their delicate, diaphanous petals. Louis C. Tiffany's innovative Favrile glass, which used variations inherent in glass as well as effects created by manipulating the molten material, makes the irises look iridescent—another word derived from the rainbow goddess's name.

			JUNE			
S	M	T	W	T	F	S
	1	2	3	4	5	6
7	8	9	10	11	12	13
14	15	16	17	18	19	20
21	22	23	24	25	26	27
28	29	30				

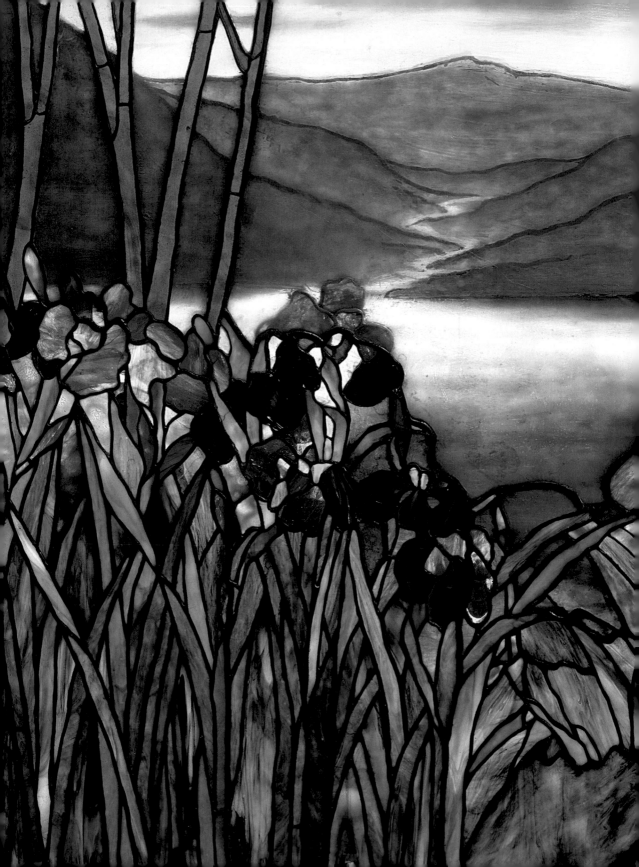

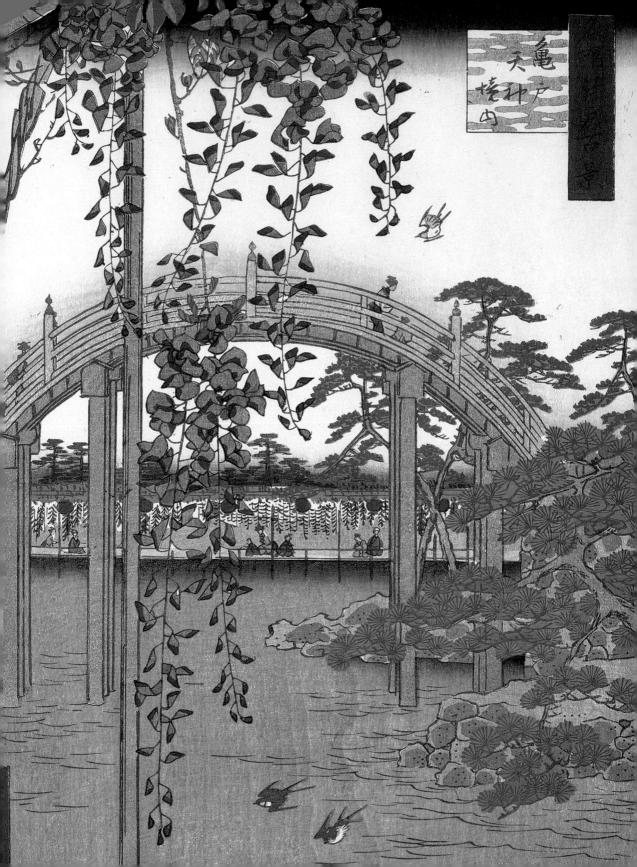

31 *Sunday*

1 *Monday*

BANK HOLIDAY (IRL)
QUEEN'S BIRTHDAY (NZ)

2 *Tuesday*

3 *Wednesday*

4 *Thursday*

5 *Friday*

○

6 *Saturday*

JUNE

S	M	T	W	T	F	S
	1	2	3	4	5	6
7	8	9	10	11	12	13
14	15	16	17	18	19	20
21	22	23	24	25	26	27
28	29	30				

LIKE THE CHERRY, wisteria has a brief blossoming season, and in 19th-century Japan, the gardens of the Kameido Tenjin Shrine were flocked with residents of Edo when its trellises were mantled with trailing purple vines. An early 20th-century visitor wrote, "I sat surrounded, almost smothered, by the blossoms, inhaling their delicious scent and listening to the droning of the bees." Wisteria can live a hundred years or more, so it is often considered a symbol of longevity.

In the Kameido Tenjin Shrine Compound (detail)
UTAGAWA HIROSHIGE
(Japanese, 1797–1858)

Polychrome woodblock print; ink and color on paper, 14 ¼ × 9 ¾ in., 1856
The Howard Mansfield Collection, Purchase, Rogers Fund, 1936 JP2517

24 *Sunday*

25 *Monday*

MEMORIAL DAY (US)
SPRING BANK HOLIDAY (UK)

26 *Tuesday*

27 *Wednesday*

28 *Thursday*

29 *Friday* ◑

30 *Saturday*

Cherry Trees (detail)
SAKAI HŌITSU (Japanese, 1761–1828)
One of a pair of six-panel folding screens; ink, color, and gold leaf on paper; 5 ft. 8 ⅞ in. × 11 ft. 9 in., early 1820s
Purchase, Mary and James G. Wallach Foundation Gift, Rogers and Mary Livingston Griggs and Mary Griggs Burke Foundation Funds, and Brooke Russell Astor Bequest, 2018 2018.55.1

THE SHORT SEASON of cherry blossoms in Japan is so anticipated that the predicted dates are discussed in newspapers and on the nightly news. Japanese art across the centuries is imbued with the awareness of the passage of time, with cherry blossoms in particular suggesting impermanence and a fleeting moment. The companion to this exquisite screen depicts crimson-leaved maple trees, the autumnal counterpart of the flowering fruit trees.

			MAY			
S	M	T	W	T	F	S
					1	2
3	4	5	6	7	8	9
10	11	12	13	14	15	16
17	18	19	20	21	22	23
24	25	26	27	28	29	30
31						

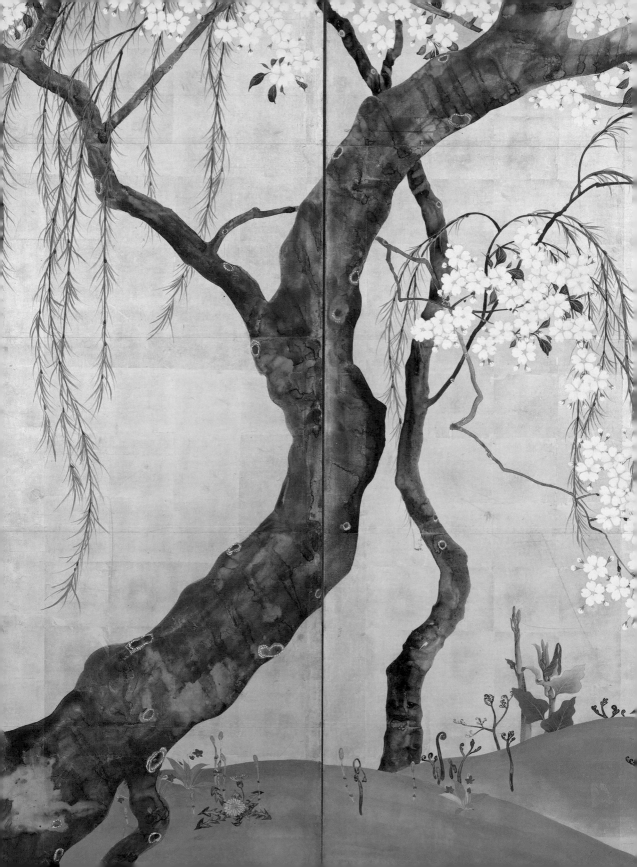

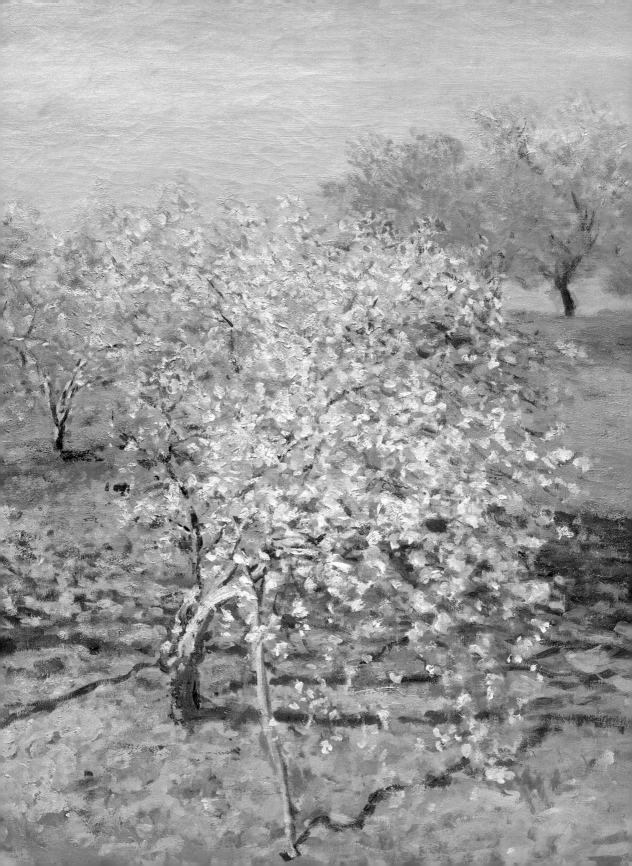

17 *Sunday*

18 *Monday*

<div align="right">VICTORIA DAY (CAN)</div>

19 *Tuesday*

20 *Wednesday*

21 *Thursday*

22 *Friday* ●

23 *Saturday*

<div align="right">EID AL-FITR (BEGINS AT SUNDOWN)</div>

MAY

S	M	T	W	T	F	S
					1	2
3	4	5	6	7	8	9
10	11	12	13	14	15	16
17	18	19	20	21	22	23
24	25	26	27	28	29	30
31						

THIS PAINTING IS practically a tutorial on Monet's oft-quoted advice to paint not the objects before you but to "merely think, here is a little square of blue, here an oblong of pink, here a streak of yellow." The blossoms are daubs of white and cream against a background of blue for the sky and splashes of green for the leaves and grass, creating a near mosaic of spring colors.

Spring (Fruit Trees in Bloom) *(detail)*

CLAUDE MONET (French, 1840–1926)

Oil on canvas, 24 ½ × 39 ⅝ in., 1873

Bequest of Mary Livingston Willard, 1926
26.186.1

10 *Sunday* MOTHER'S DAY (US, CAN, AUS, NZ)

11 *Monday*

12 *Tuesday*

13 *Wednesday*

14 *Thursday* ◑

15 *Friday*

16 *Saturday*

Gathering Fruit (detail)
MARY CASSATT
(American, 1844–1926)
Drypoint, softground etching, and
aquatint, 20 ½ × 15 ⅞ in., ca. 1893
Rogers Fund, 1918 18.33.4

CHILDREN ADORE PICKING fruit, whether
apples in the autumn or berries in the summer—
though the latter frequently end up in the mouth
rather than the basket. In Cassatt's depiction of
this simple pleasure, a woman climbs a ladder
against a wall with an espaliered pear tree and a
climbing grapevine and hands a bunch of grapes
down to the baby, whose bare bottom is as round
as the bulbous pears.

MAY

S	M	T	W	T	F	S
					1	2
3	4	5	6	7	8	9
10	11	12	13	14	15	16
17	18	19	20	21	22	23
24	25	26	27	28	29	30
31						

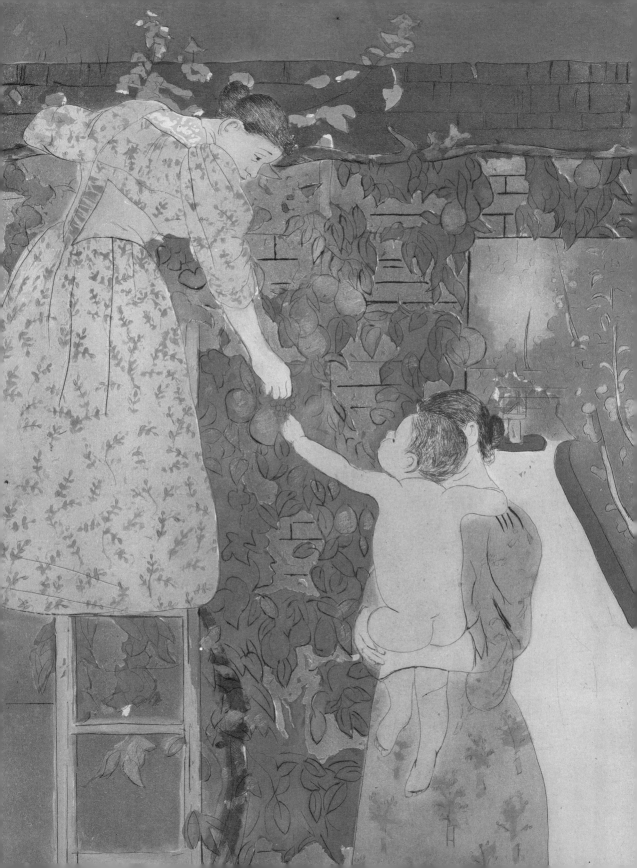

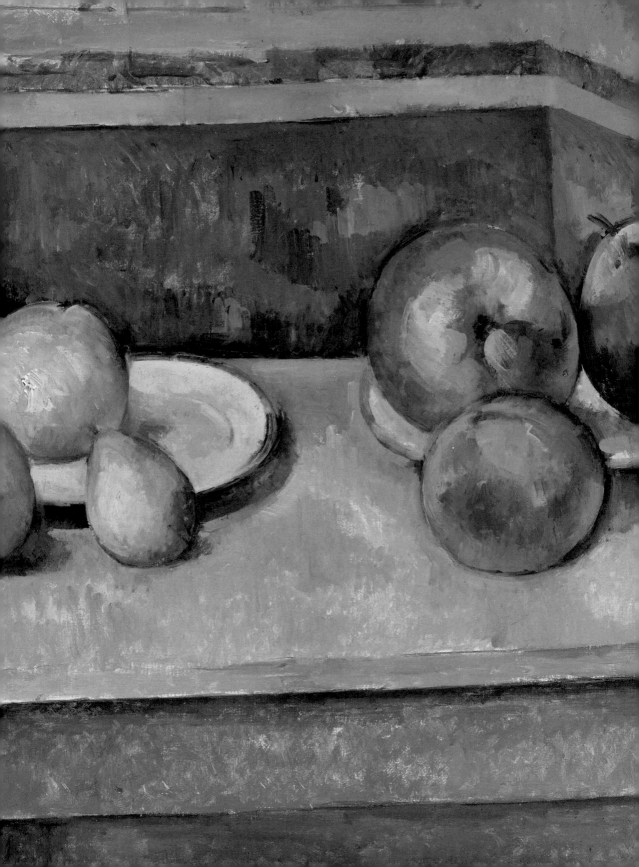

3 *Sunday*

4 *Monday* EARLY MAY BANK HOLIDAY (UK, IRL)

5 *Tuesday*

6 *Wednesday*

7 *Thursday* ○

8 *Friday*

9 *Saturday*

MAY

S	M	T	W	T	F	S
					1	2
3	4	5	6	7	8	9
10	11	12	13	14	15	16
17	18	19	20	21	22	23
24	25	26	27	28	29	30
31						

CÉZANNE USED AND reused objects—including apples—in his still lifes as he explored problems of composition and perspective. Here the table is depicted as if seen from above, while the pieces of fruit are painted straight on, making viewers wonder uneasily if the apples and pears are going to roll downhill into their laps. Cézanne added pears to his familiar apples, as their asymmetrical shape changed the rhythm of the round forms.

Still Life with Apples and Pears (detail)
PAUL CÉZANNE (French, 1839–1906)
Oil on canvas, 17 ⅝ × 23 ⅛ in., ca. 1891–92
Bequest of Stephen C. Clark, 1960 61.101.3

26 *Sunday*

27 *Monday* ANZAC DAY OBSERVED (AUS, NZ)

28 *Tuesday*

29 *Wednesday*

30 *Thursday* ◐

1 *Friday*

2 *Saturday*

Still Life with Strawberries
(detail)
FRENCH, 17th century
Oil on canvas, 23 ⅝ × 31 ⅝ in.
Bequest of Harry G. Sperling, 1971
1976.100.10

WHILE MANY STILL-LIFE paintings include flowers and fruit that couldn't possibly bloom or ripen at the same time of year, this unknown—and perhaps humble—artist limned an endearing encomium to spring. The compote brimming with strawberries complete with their flowers is surrounded by vernal blossoms and by stalks of asparagus, plump peapods, and an artichoke—foodstuffs in season for all-too-short a time.

			MAY			
S	M	T	W	T	F	S
					1	2
3	4	5	6	7	8	9
10	11	12	13	14	15	16
17	18	19	20	21	22	23
24	25	26	27	28	29	30
31						

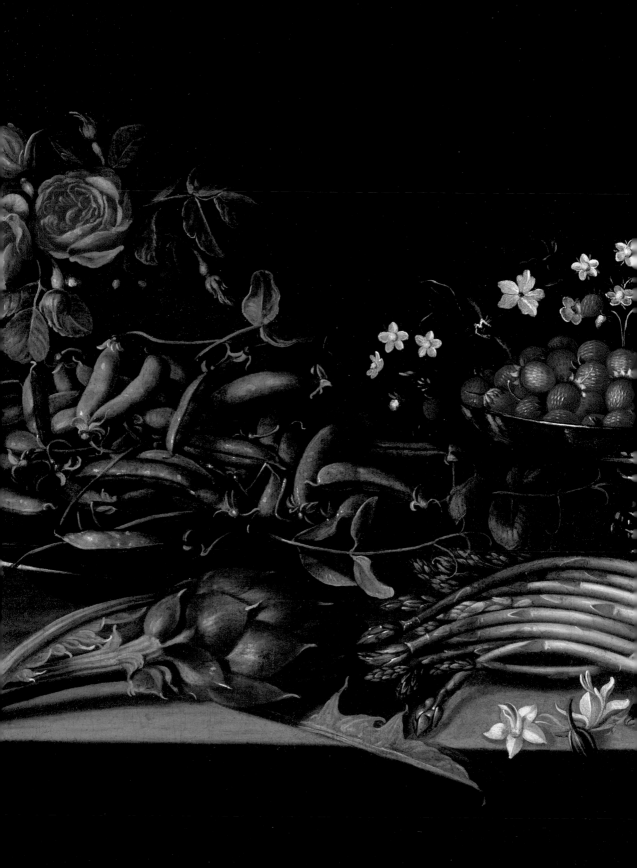

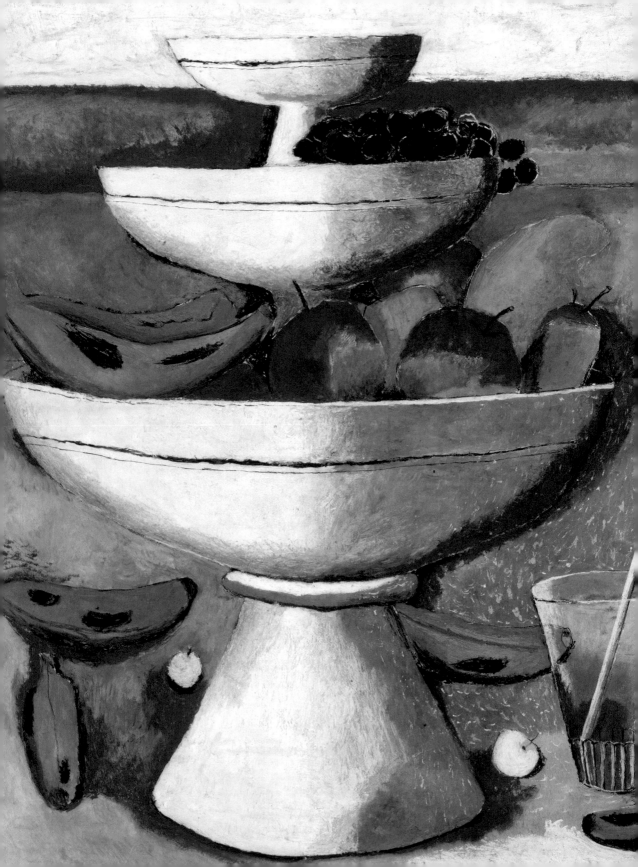

19 *Sunday*

20 *Monday*

21 *Tuesday*

22 *Wednesday* EARTH DAY
●

23 *Thursday* RAMADAN (BEGINS AT SUNDOWN)

24 *Friday*

25 *Saturday* ANZAC DAY (AUS, NZ)

APRIL

S	M	T	W	T	F	S
			1	2	3	4
5	6	7	8	9	10	11
12	13	14	15	16	17	18
19	20	21	22	23	24	25
26	27	28	29	30		

AS A BOY, Tamayo lived in Mexico City with an aunt who had a wholesale fruit business, and it was there that his fondness for tropical fruit arose. But yellow bananas and ruddy apples also reveal the inspiration he found in the color and light of Mexico and the beauty of simple things. As the poet Octavio Paz wrote of him, "the sun is in all his pictures."

The White Fruit Bowl (detail)
RUFINO TAMAYO
(Mexican, 1899–1991)

Oil on canvas, 18 × 23 ⅝ in., 1938

| 12 | Sunday | EASTER SUNDAY |

| 13 | Monday | EASTER MONDAY |

| 14 | Tuesday | ◑ |

| 15 | Wednesday | |

| 16 | Thursday | |

| 17 | Friday | |

| 18 | Saturday | |

Dogwood (detail)
LOUIS COMFORT TIFFANY
(American, 1848–1933)
Made by TIFFANY STUDIOS
(American, 1902–1932)

Leaded Favrile glass,
8 ft. 4 in. × 4 ft. 8 in., ca. 1902–15
Gift of Frank Stanton, in memory of Ruth
Stephenson Stanton, 1995 1995.204

DOGWOOD IS ONE of several trees said to have been used for the cross on which Christ was crucified. Its flowers are cross-like in shape, and each petal has a small, rust-colored spot, suggestive of a drop of blood from a nail wound. Louis C. Tiffany drew on myriad types of glass invented in his studios—fractured or "confetti," rippled, and opalescent—to achieve subtle effects of light and texture.

APRIL

S	M	T	W	T	F	S
			1	2	3	4
5	6	7	8	9	10	11
12	13	14	15	16	17	18
19	20	21	22	23	24	25
26	27	28	29	30		

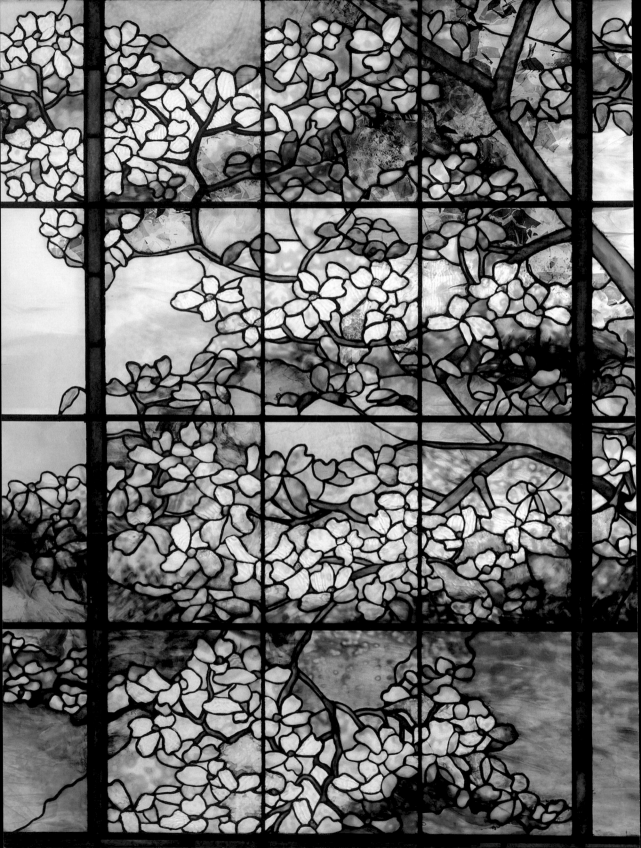

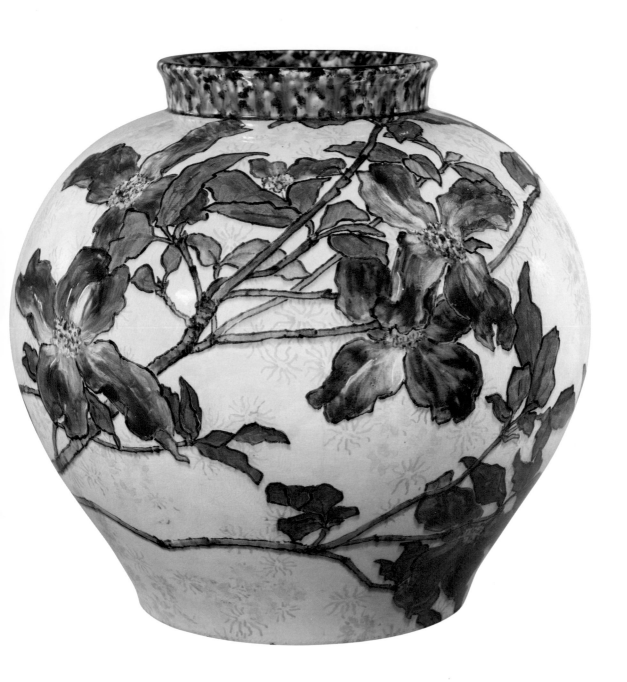

5 *Sunday* PALM SUNDAY

6 *Monday*

7 *Tuesday* ○

8 *Wednesday* PASSOVER (BEGINS AT SUNDOWN)

9 *Thursday*

10 *Friday* GOOD FRIDAY

11 *Saturday*

APRIL

S	M	T	W	T	F	S
			1	2	3	4
5	6	7	8	9	10	11
12	13	14	15	16	17	18
19	20	21	22	23	24	25
26	27	28	29	30		

BENNETT CAME TO New York from Britain, and he brought with him the aspirations of the Arts and Crafts movement—to invest everyday objects with beauty and exquisite craftsmanship. These pink-and-white dogwood blossoms, stylized and flattened and with dark outlines, rest on a delicate sprig-patterned background, reminiscent of a William Morris wallpaper.

Vase
JOHN BENNETT
(American, 1840–1907)
Painted and glazed earthenware, 1882
Friends of the American Wing Fund, 1984
1984.425

29 Sunday SUMMER TIME BEGINS (UK, IRL)

30 Monday

31 Tuesday

1 Wednesday ◑

2 Thursday

3 Friday

4 Saturday

Pink Azalea—Chinese Vase
(detail)
WILLIAM MERRITT CHASE
(American, 1849–1916)

Oil on wood, 23 ½ × 16 ⁹⁄₁₆ in.,
1880–90?

Gift of Mrs. J. Augustus Barnard, 1979
1979.490.5

PETER KALM, THE protégé of Linnaeus sent by
the Swedish government to explore the plants of
North America in 1748, said of azaleas: "The peo-
ple have not found that this plant may be applied
to any practical use; they only gather the flowers
and put them in pots because they are so beauti-
ful." Chase may have agreed.

APRIL

S	M	T	W	T	F	S
			1	2	3	4
5	6	7	8	9	10	11
12	13	14	15	16	17	18
19	20	21	22	23	24	25
26	27	28	29	30		

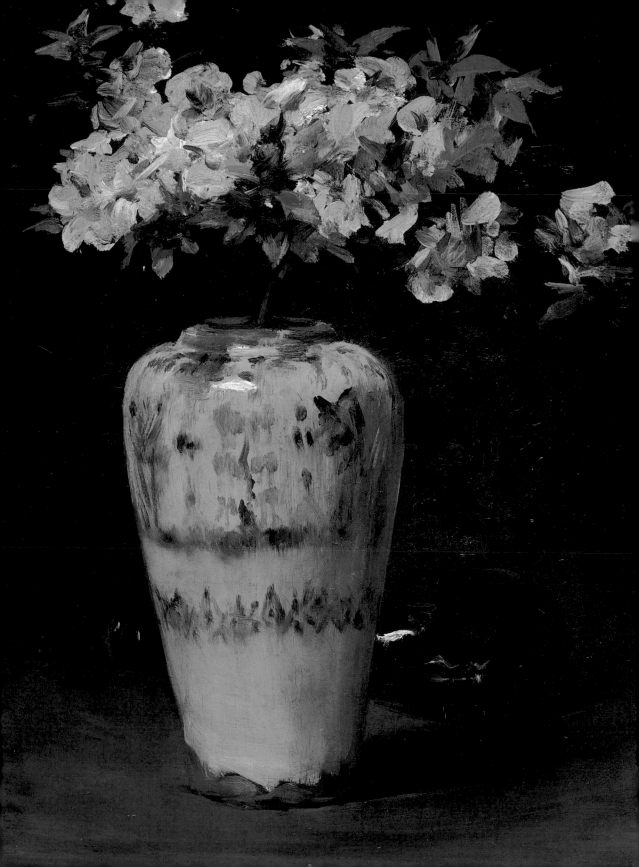

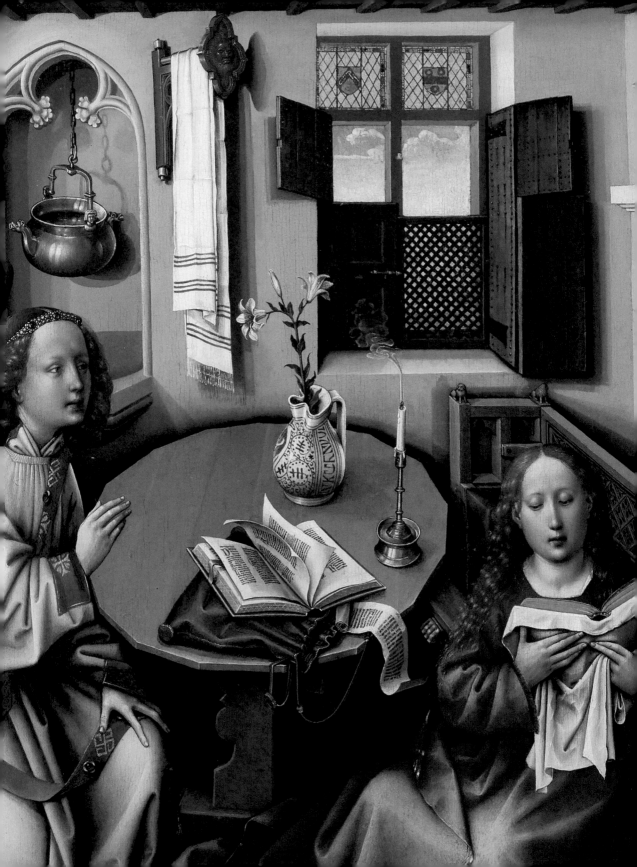

22 *Sunday*

23 *Monday*

24 *Tuesday* ●

25 *Wednesday*

26 *Thursday*

27 *Friday*

28 *Saturday*

MARCH

S	M	T	W	T	F	S
1	2	3	4	5	6	7
8	9	10	11	12	13	14
15	16	17	18	19	20	21
22	23	24	25	26	27	28
29	30	31				

THE MADONNA LILY, *Lilium candidum*, has appeared in art as far back as the Minoan civilization. With its milk-white flowers and a fragrance similar to frankincense, the lily in Christian art represents the purity of the Virgin Mary—hence the name—and few representations of the Annunciation fail to include one. In this Early Netherlandish masterpiece, the pitcher of lilies is flanked by a candle, its flame recently snuffed by the unexpected arrival of the Holy Spirit.

Annunciation Triptych (Merode Altarpiece) (detail)
Workshop of ROBERT CAMPIN
(Netherlandish, ca. 1375–1444)
Oil on oak; overall (open):
25 ⅜ × 46 ⅜ in., ca. 1427–32
The Cloisters Collection, 1956 56.70a–c

15 *Sunday*

16 *Monday* ◑

17 *Tuesday* ST. PATRICK'S DAY (IRL, N. IRL)

18 *Wednesday*

19 *Thursday*

20 *Friday* VERNAL EQUINOX

21 *Saturday*

Basket of Bananas (detail)
PIERRE BONNARD
(French, 1867–1947)

Oil on canvas, 23 ⅝ × 25 ¼ in., 1926

Jacques and Natasha Gelman Collection, 1998 1999.363.7
© 2019 Artists Rights Society (ARS), New York

MANY OF BONNARD'S domestic scenes show people sitting at a table or gathered around a table's edge. Here, the only hint of occupation is an empty chair. The focus is all on the bananas, their color emphasized by the golden vessel, the creamy plate, and the yellow-and-white pattern underneath the red-and-white checked cloth.

MARCH

S	M	T	W	T	F	S
1	2	3	4	5	6	7
8	9	10	11	12	13	14
15	16	17	18	19	20	21
22	23	24	25	26	27	28
29	30	31				

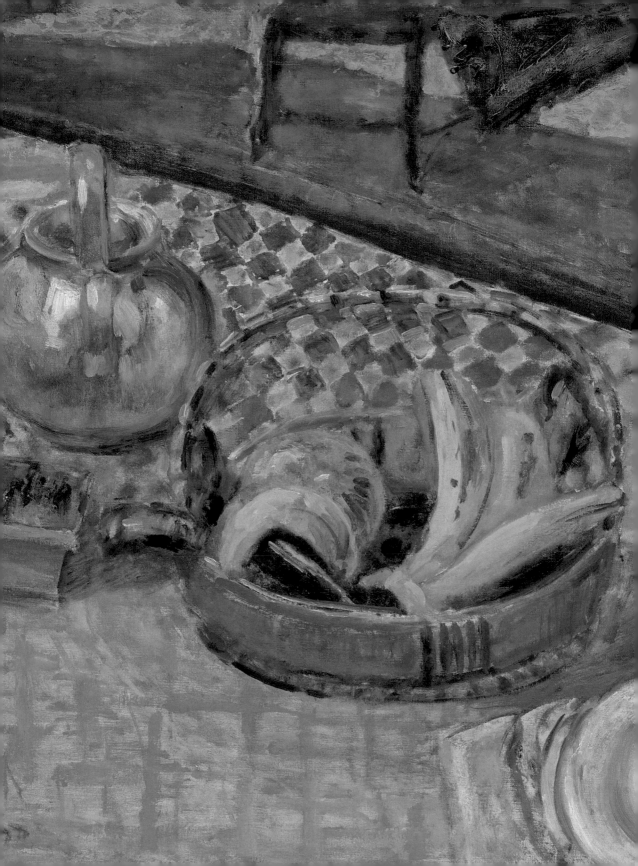

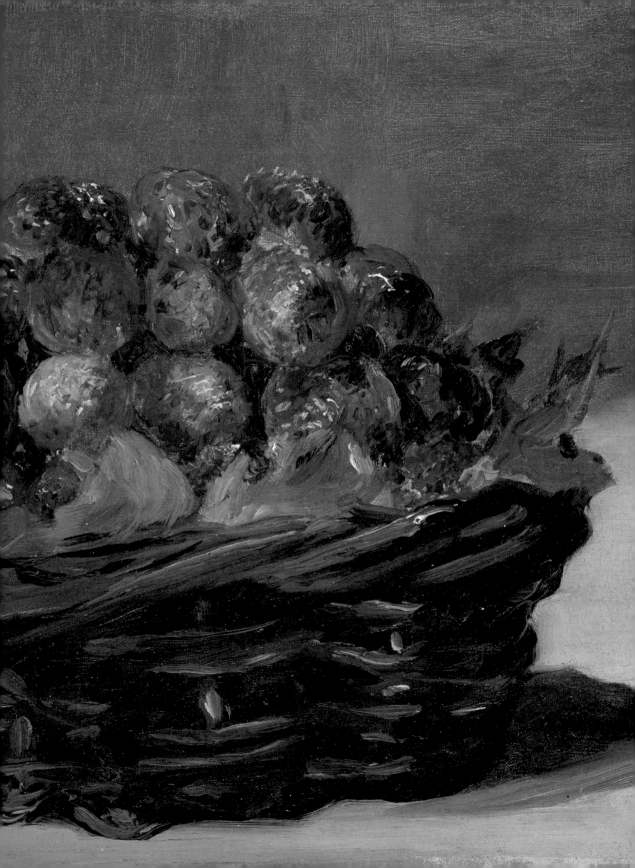

8 *Sunday* DAYLIGHT SAVING TIME BEGINS (US, CAN)

9 *Monday* PURIM (BEGINS AT SUNDOWN)
COMMONWEALTH DAY (CAN, UK, AUS, NZ)
○

10 *Tuesday*

11 *Wednesday*

12 *Thursday*

13 *Friday*

14 *Saturday*

MARCH

S	M	T	W	T	F	S
						1
1	2	3	4	5	6	7
8	9	10	11	12	13	14
15	16	17	18	19	20	21
22	23	24	25	26	27	28
29	30	31				

IN THE LAST years of his life, when illness compelled him to stay indoors, Manet turned again to still lifes, often of bouquets that friends had brought him, painting on small canvases so he could work while seated. This poignantly lovely image is deceptively simple, with its setting undefined, its background divided into dark and light halves, and the off-center basket.

Strawberries (detail)
ÉDOUARD MANET
(French, 1832–1883)
Oil on canvas, 8 ⅜ × 10 ½ in., ca. 1882
Gift of Mr. and Mrs. Nate B. Spingold, 1956
56.230.1

1 *Sunday*

2 *Monday* ◑

3 *Tuesday*

4 *Wednesday*

5 *Thursday*

6 *Friday*

7 *Saturday*

Bouquet of Flowers (detail)
ODILON REDON (French, 1840–1916)
Pastel on paper, 31 ⅝ × 25 ¼ in.,
ca. 1900–1905
Gift of Mrs. George B. Post, 1956 56.50

REDON'S INFLUENCES INCLUDED the symbolist poetry of Charles Baudelaire and insights gleaned from a botanist friend, Armand Clavaud. Though his flowers can be identified, they take on an otherworldly aura. Redon said, "It is only after making an effort of will to represent with minute care a grass blade, a stone, a branch, the face of an old wall, that I am overcome by the irresistible urge to create something imaginary."

MARCH

S	M	T	W	T	F	S
1	2	3	4	5	6	7
8	9	10	11	12	13	14
15	16	17	18	19	20	21
22	23	24	25	26	27	28
29	30	31				

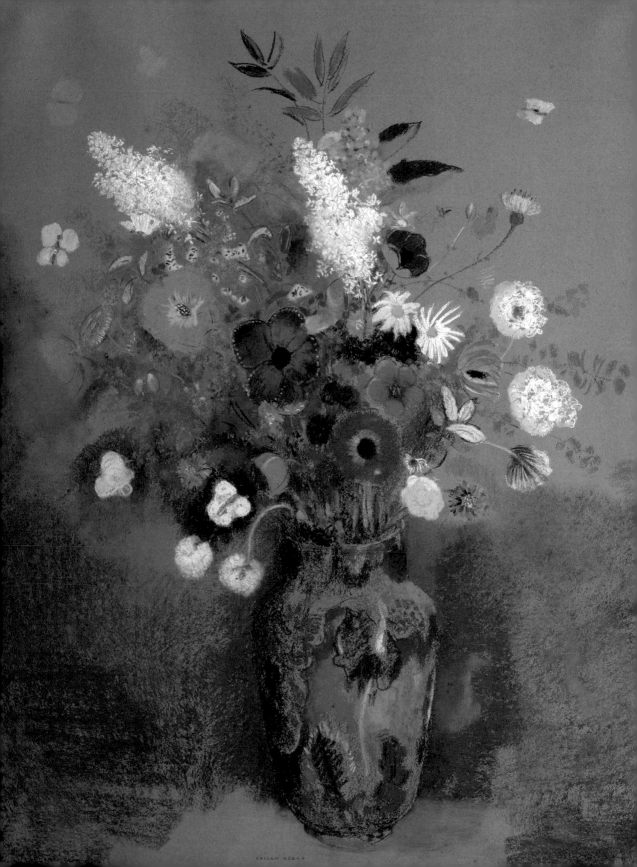

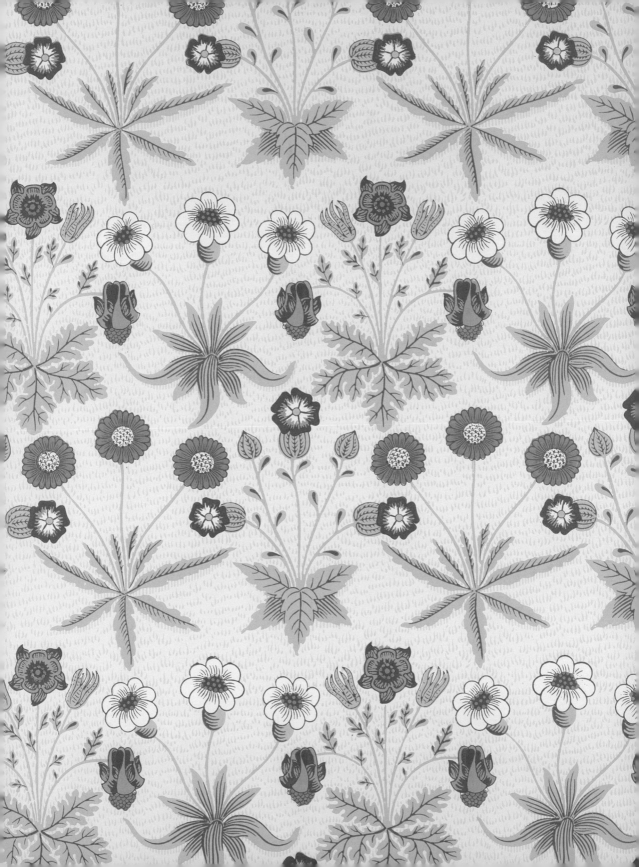

23	*Sunday*	●

24	*Monday*

25	*Tuesday*

26	*Wednesday*	ASH WEDNESDAY

27	*Thursday*

28	*Friday*

29	*Saturday*

FEBRUARY

S	M	T	W	T	F	S
						1
2	3	4	5	6	7	8
9	10	11	12	13	14	15
16	17	18	19	20	21	22
23	24	25	26	27	28	29

THIS WAS THE second wallpaper pattern Morris designed, and the first to be produced. Although wallpaper was experiencing a boom in popularity in 1860s Britain, it was primarily a French style that was in fashion with exotic blooms, opulent colors, and even trompe l'oeil. Morris preferred flat, stylized patterns and simple, everyday flowers, such as these, which might be found in English gardens and hedgerows.

Daisy (detail)
WILLIAM MORRIS (British, 1834–1896)
Made by MORRIS & COMPANY
Block-printed wallpaper, 27 × 21 ½ in.,
designed 1864
Purchase, Edward C. Moore Jr. Gift, 1923
23.163.4b

16 *Sunday*

17 *Monday* PRESIDENTS' DAY (US)

18 *Tuesday*

19 *Wednesday*

20 *Thursday*

21 *Friday*

22 *Saturday*

A Vase of Flowers (detail)
MARGARETA HAVERMAN
(Dutch, active by 1716–d. 1722 or later)
Oil on wood, 31 ¼ × 23 ¾ in., 1716
Purchase, 1871 71.6

ONLY TWO PAINTINGS are known to be by Haverman, a student of the illustrious flower painter Jan van Huysum. Here, roses, carnations, marigolds, poppies, and a crowning red-striped tulip, among others, are depicted with extraordinary attention. A close look shows the veins on the leaves, the individual stigmas and stamens on a passionflower, and the transparent wings of a bumblebee. The apple and grapes resting on the ledge have attracted a couple of ants.

FEBRUARY

S	M	T	W	T	F	S
						1
2	3	4	5	6	7	8
9	10	11	12	13	14	15
16	17	18	19	20	21	22
23	24	25	26	27	28	29

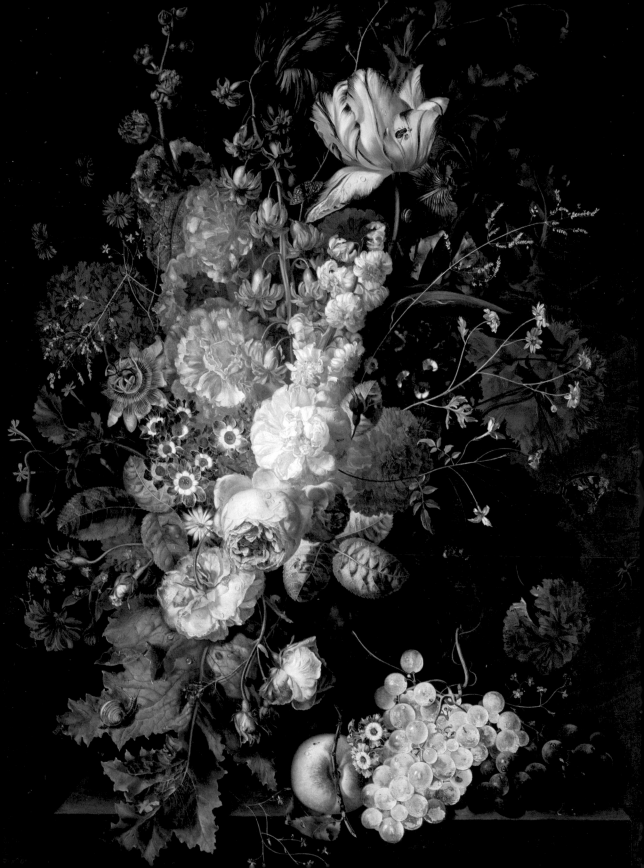

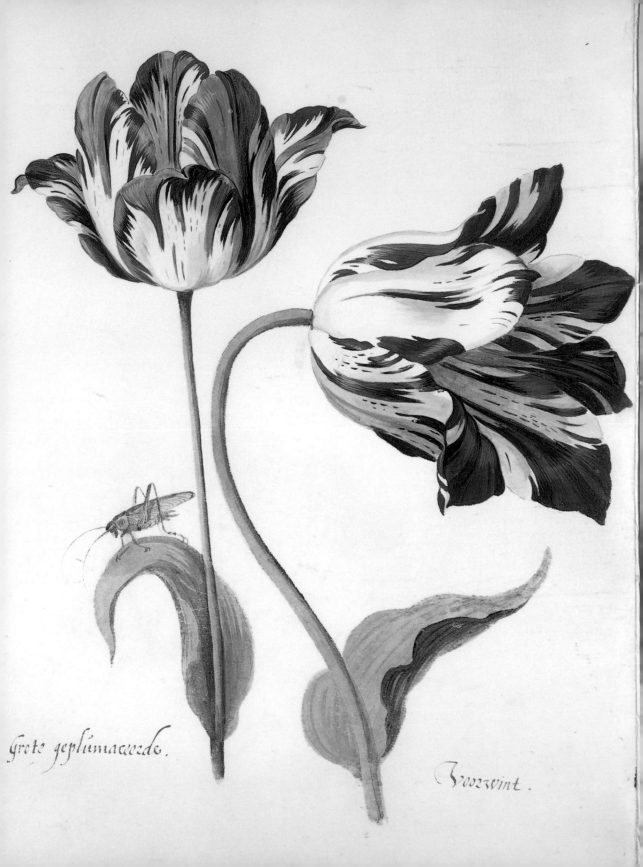

Grote geplumaceerde.

Voorwint.

9	*Sunday* ○
10	*Monday*
11	*Tuesday*
12	*Wednesday*
13	*Thursday*
14	*Friday* VALENTINE'S DAY
15	*Saturday* ◐

FEBRUARY

S	M	T	W	T	F	S
						1
2	3	4	5	6	7	8
9	10	11	12	13	14	15
16	17	18	19	20	21	22
23	24	25	26	27	28	29

TULIPS SET FOOT upon the European stage in the 1550s and immediately became the divas of horticulture, coveted and cosseted by collectors. Particularly prized were "broken" tulips—those with striped or flamed flowers. Those with red flames on white, like these, were especially valuable. Unknown to growers, however, these much-admired color variations were caused by a virus carried by aphids.

Four Tulips: Grote geplumaceerde (The Great Plumed One) and Voorwint (With the Wind) (detail)
JACOB MARREL (German, 1613/14–1681)
Watercolor on vellum, 13 3/8 × 17 11/16 in., ca. 1635–45
Rogers Fund, 1968 68.66

2 *Sunday* GROUNDHOG DAY (US, CAN)

3 *Monday*

4 *Tuesday*

5 *Wednesday*

6 *Thursday* WAITANGI DAY (NZ)

7 *Friday*

8 *Saturday*

One Hundred Flowers (detail)
After YUN SHOUPING
(Chinese, 1633–1690)
Handscroll, ink and color on silk,
1 ft. 4 ½ in. × 21 ft. 3 ½ in., 18th century
Bequest of John M. Crawford, Jr., 1988
1989.363.149

SO MANY FLOWERING plants are native to China that the country is known as the "Mother of Gardens"; this handscroll conveys that munificence. More than 20 feet long, it really does seem to show 100 flowers. Handscrolls are meant to be looked at section by section, unrolling as you go, mimicking the experience of strolling through a garden.

FEBRUARY

S	M	T	W	T	F	S
						1
2	3	4	5	6	7	8
9	10	11	12	13	14	15
16	17	18	19	20	21	22
23	24	25	26	27	28	29

| 26 | Sunday | AUSTRALIA DAY (AUS) |

| 27 | Monday | AUSTRALIA DAY OBSERVED (AUS) |

| 28 | Tuesday |

| 29 | Wednesday |

| 30 | Thursday |

| 31 | Friday |

| 1 | Saturday | ◑ |

FEBRUARY

S	M	T	W	T	F	S
						1
2	3	4	5	6	7	8
9	10	11	12	13	14	15
16	17	18	19	20	21	22
23	24	25	26	27	28	29

WITH PALE GOLD and deep rosy hues, Renoir's velvety peaches—and a few cooperative pears—just about hold their own against an elaborate background; in fact, the almost-showy wallpaper echoes the colors of the fruit. The blue-and-white jardinière is a reminder that Renoir began his career painting porcelain.

Still Life with Peaches (detail)
AUGUSTE RENOIR
(French, 1841–1919)
Oil on canvas, 21 × 25 ½ in., 1881
Bequest of Stephen C. Clark, 1960 61.101.12

19 *Sunday*

20 *Monday* MARTIN LUTHER KING JR. DAY (US)

21 *Tuesday*

22 *Wednesday*

23 *Thursday*

24 *Friday* ●

25 *Saturday* LUNAR NEW YEAR (YEAR OF THE RAT)

Peonies (detail)
ÉDOUARD MANET
(French, 1832–1883)
Oil on canvas, 23 ⅜ × 13 ⅞ in., 1864–65
Bequest of Joan Whitney Payson, 1975
1976.201.16

PEONIES HAVE BEEN cultivated for millennia in China, where they are called "the king of flowers and the flower of kings." When they appeared in France in the early 19th century, they were regarded as the essence of luxury. Manet, who grew them in his garden and painted some 15 pictures of them, may have found that their broad petals and leaves lent themselves to his use of a wide brush and his loose, fluid brushstrokes.

JANUARY

S	M	T	W	T	F	S	
				1	2	3	4
5	6	7	8	9	10	11	
12	13	14	15	16	17	18	
19	20	21	22	23	24	25	
26	27	28	29	30	31		

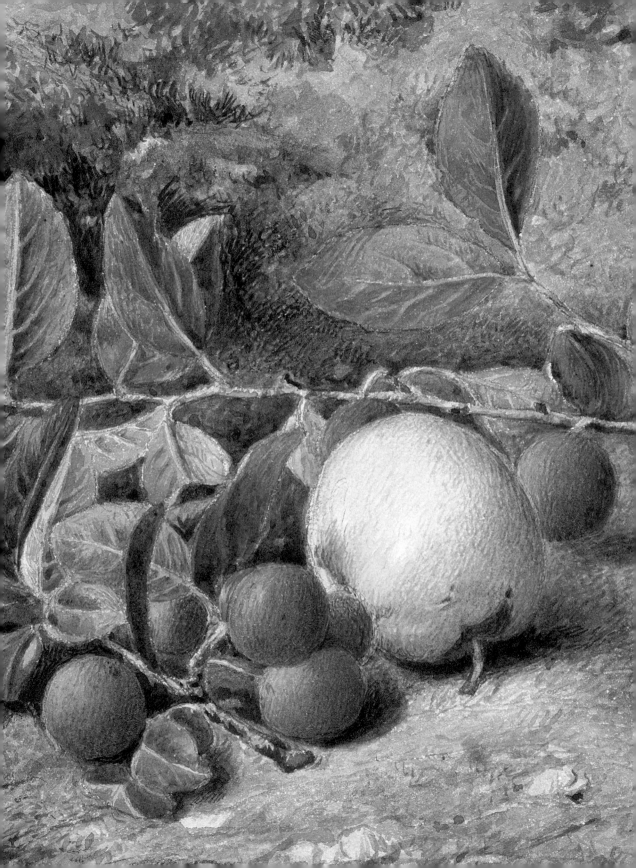

12 *Sunday*

13 *Monday*

14 *Tuesday*

15 *Wednesday*

16 *Thursday*

17 *Friday*

18 *Saturday*

JANUARY							
S	M	T	W	T	F	S	
				1	2	3	4
5	6	7	8	9	10	11	
12	13	14	15	16	17	18	
19	20	21	22	23	24	25	
26	27	28	29	30	31		

AFTER ENCOUNTERING THE writings of John Ruskin and the work of the Pre-Raphaelites, who advocated "truth to nature," Hill moved from painting precise, almost topographical, landscapes to humble subjects in informal compositions. These plums—perhaps greengage and damson—appear to have fallen from their tree, complete with branch and leaves, and they look so delectable that we are tempted to pick them up, dust them off, and bite into them.

Plums (detail)
JOHN WILLIAM HILL
(American, b. England, 1812–1879)
Watercolor, graphite, and gouache,
7 ⅛ × 12 in., 1870
Gift of J. Henry Hill, 1882 82.9.1

5 *Sunday*

6 *Monday*

7 *Tuesday*

8 *Wednesday*

9 *Thursday*

10 *Friday* ○

11 *Saturday*

Black Iris
GEORGIA O'KEEFFE
(American, 1887–1986)
Oil on canvas, 36 × 29 ⅞ in., 1926
Alfred Stieglitz Collection, 1969 69.278.1

NO FLOWER IS actually black—those we call black are really very dark purple—but the idea is intriguing. O'Keeffe searched New York's flower markets to find a black iris, a species that blooms for a brief time in spring, and she painted several versions of it. Its rarity and elusiveness contribute to the mystique that pervades this painting.

JANUARY

S	M	T	W	T	F	S
			1	2	3	4
5	6	7	8	9	10	11
12	13	14	15	16	17	18
19	20	21	22	23	24	25
26	27	28	29	30	31	

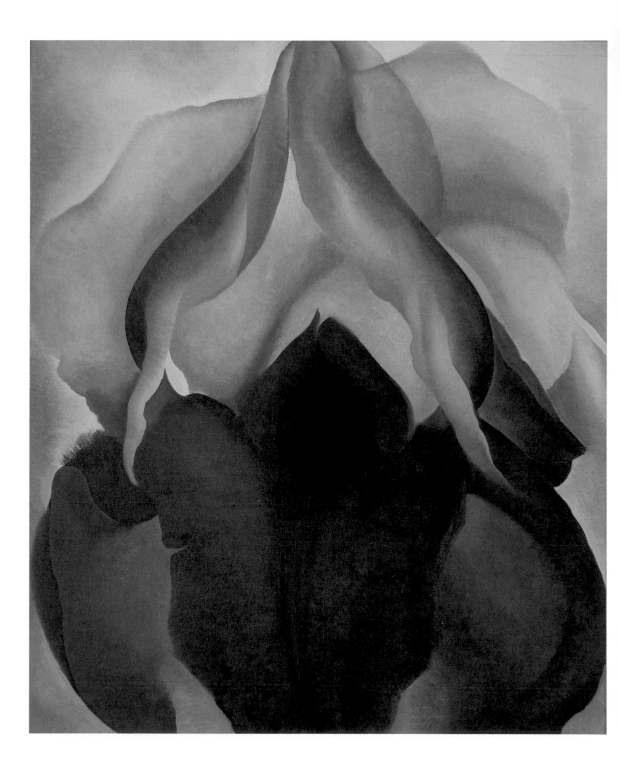

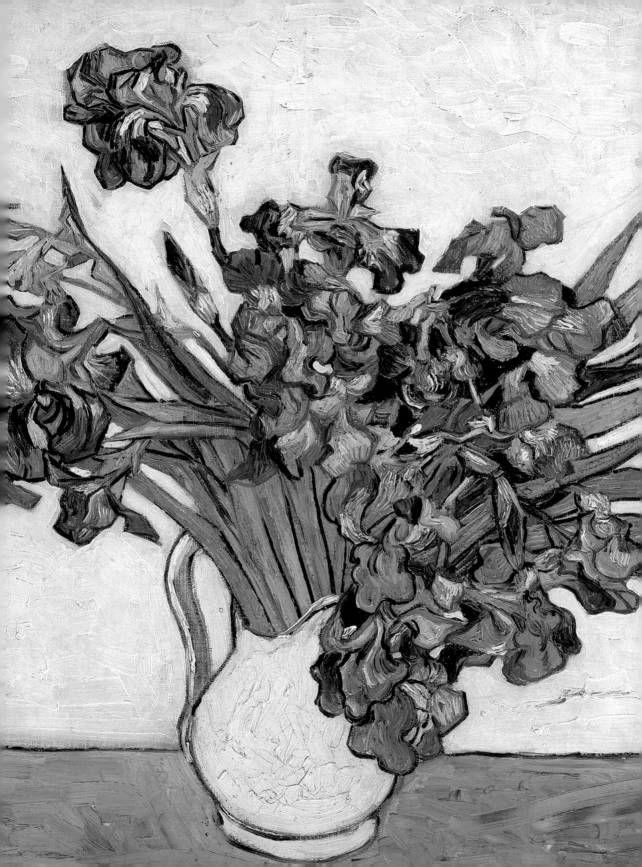

29 *Sunday*

30 *Monday*

31 *Tuesday*

1 *Wednesday* NEW YEAR'S DAY

2 *Thursday* BANK HOLIDAY (SCT, NZ)
 ◑

3 *Friday*

4 *Saturday*

JANUARY

S	M	T	W	T	F	S
			1	2	3	4
5	6	7	8	9	10	11
12	13	14	15	16	17	18
19	20	21	22	23	24	25
26	27	28	29	30	31	

JUST BEFORE VAN GOGH left the asylum near Saint-Rémy, where he had spent a turbulent year, he felt well enough to paint. He was enthusiastic about a group of still lifes that included two of roses and two of irises—in this one, he said, the overall effect was "soft and harmonious." The confident and fluid brushstrokes seem indicative of the artist's equable state—his doctors had pronounced him cured, though sadly, this did not prove to be true.

Irises (detail)
VINCENT VAN GOGH
(Dutch, 1853–1890)
Oil on canvas, 29 × 36 ¼ in., 1890
Gift of Adele R. Levy, 1958 58.187

 # INTRODUCTION

"A painter can express all that he wants to with fruit or flowers."
ÉDOUARD MANET

Familiar articles of daily life, easily found and obtained, fruits and flowers have been favored as subjects in art since ancient times. They invite artists to express the beauty of the natural world, to exhibit technical virtuosity, and to explore aesthetic issues. Burgeoning plants and succulent fruits are evidence of nature's gifts, of growth and renewal, and of sustenance and comfort.

Fruits and flowers exist in a cornucopia of colors and shapes. Even the ordinary apple grows in dozens of shades from Granny Smith–green to delicious red. An artist with a gap in the canvas can fill it with a puffy peony or a simple snowdrop, a striped tulip or a checked fritillary, a plump peach or glossy grapes. Unlike human subjects, fruits and flowers stay in place and don't fidget, nor can the artist offend their sensibilities by depicting their blemishes. And as even the most determined plein air painter—that is, Monet—found, fruits and flowers lend themselves to being painted indoors when weather interferes with outdoor excursions.

The prettiness of some fruit and flower paintings belies their makers' rigorous attention to artistic concerns such as composition, light, and paint handling, and they reward closer scrutiny. While some may seem like casual arrangements, many, like those by Monet or Janet Fish, are thoughtfully organized with a view to rendering the way light defines delicate petals or is reflected off vases and bowls. For Cézanne, who said, "I want to astonish Paris with an apple," the rounded fruits, some imperfect and asymmetrical, lent themselves to his method of using short strokes and gradations of color to define shape and volume. Georgia O'Keeffe took the forms and colors of fruits and flowers and turned those solid objects into abstractions.

Renoir said, "I just let my brain rest when I paint flowers." That may be a slight exaggeration, given his bountiful bouquets, but it is a sage suggestion for viewers. Turning from week to week in this calendar, recording appointments and engagements, take a moment to let the mind rest and admire these glorious works of art.

Still Life with Flowers and Fruit (detail)
HENRI FANTIN-LATOUR (French, 1836–1904)
Oil on canvas, 28 ¾ × 23 ⅝ in., 1866
Purchase, Mr. and Mrs. Richard J. Bernhard Gift, by exchange, 1980 1980.3

UNLIKE HIS CONTEMPORARIES who painted in nature, Fantin-Latour preferred to work in the studio, where he could set up his subjects to suit him and paint them with closely observed detail. "I tried to make a painting representing things as they are found in nature; I put a great deal of thought into the arrangement, but with the idea of making it look like a natural arrangement of random objects."